CLASSIC CALLIGRAPHY
FOR BEGINNERS

Essential Step-by-Step Techniques
for Copperplate and Spencerian Scripts

Younghae Chung

QUARRY

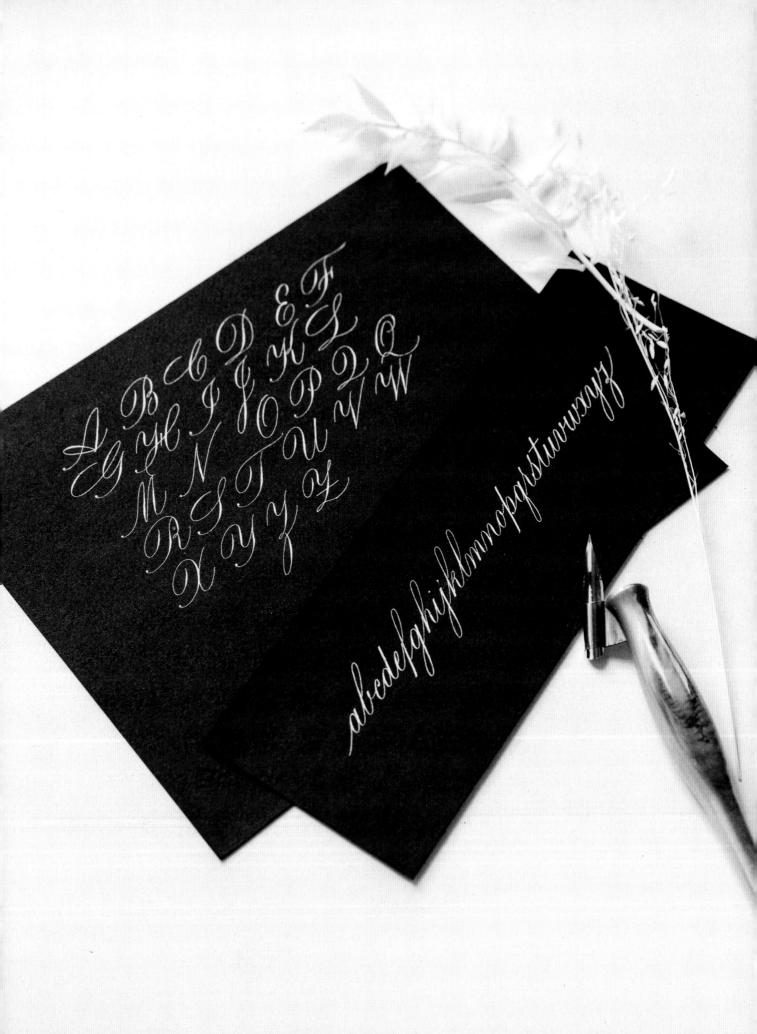

Contents

Introduction

Back in 2005, when I was a senior at Tufts University, I remember scrolling through different class electives, wondering what fun classes I should take before graduating. I heard about a calligraphy class that would be an easy A, and intrigued, I signed up to learn Italic calligraphy for the first time. That semester, I learned how to write letters with a broad-edge nib, practiced writing out words and sentences, and ended with a finished project. I received an A, but more than that, I really enjoyed the class because it gave me a break from the rigorous academic classes that I was used to.

Fast forward to 2014. I never thought taking that one calligraphy class in my 20s would come back into my life in my 30s when I was a mom of two young boys. Our family was working through some medical issues with our youngest boy, and we were staying at a short-term rental apartment in Florida. Looking around our dreary and empty walls, I had a longing to write out words from Scripture, words of hope and encouragement to hang as visual reminders not to give up.

In that moment, I had a flashback to the Italic calligraphy class, which led me to do a Google search for "local calligraphy class in Orlando." The first advertisement that popped up was from an art shop for a Copperplate Calligraphy Workshop with Kaye Hanna. I had no idea what "copperplate" was, but I was captivated by the beauty of the script. It was my first time learning how to write with a pointed nib, but I was instantly hooked. This became my newfound joy and a daily outlet for me to slow down, meditate, and practice while the boys were asleep.

Logos Calligraphy & Design officially launched in January 2016. As *logos* in Greek means "the Word" (John 1:1), my hope and vision is that calligraphy would bring the same encouragement, hope, and beauty to others as it did in my life. Over the past years, not only has it been a joy connecting with thousands of students worldwide, but I've also been able to learn more about my great uncle, Song, Seong Yong, his legacy in Korea, and the impact he had as the last traditional scholar, calligrapher, and painter in the twentieth century. Song, Seong

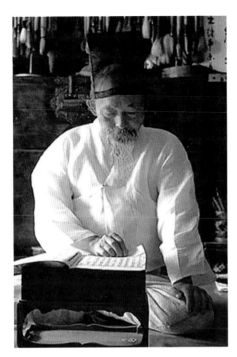

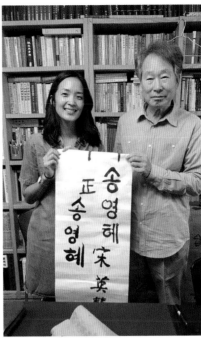

(*left*) My great uncle, Song, Seong Yong (1913–1999)

(*right*) The author with Song, Ha Kyung, 2018

Yong (1913–1999), was well known for developing his own calligraphy script style called Gangam, which was named after his pen name. He dedicated his life to preserving calligraphy and promoting it to younger generations, and he established the Gangam Calligraphy Center and Gangam Calligraphy Research Foundation. Thousands of his works are scattered throughout Korea, and my parents have a handful of his original works hanging in their home. In 2018, I had an opportunity to meet with his son, Song, Ha Kyung, who is a retired professor, author, and calligrapher. Though we are generationally and culturally different, I love that we were able to come together and share in our love for calligraphy.

This journey has been unexpected but filled with joy and new opportunities. Now, I'm thrilled to share a bit of my heart with you through this book. In this book, we cover two of my favorite pointed pen scripts: Copperplate and Spencerian. These scripts are different but complement each other nicely. We begin with the foundation, from gathering the right supplies, to performing warm-up exercises, to understanding the basic strokes and learning how to form the lowercase and uppercase letters. In the latter half of the book, I share fun and creative ways to use calligraphy for various projects. The projects are grouped into three categories: nib, brush, and pen. What's great is that calligraphy isn't confined to the nib, and I show how you can emulate calligraphy using a variety of writing tools.

I encourage you to *enjoy the journey*. Progress over perfection has always been my mantra, and it has helped me push through when things got difficult. I also tell my students to give themselves time and grace. My script has changed and developed so much over time, and even with these classic scripts, we can each leave our unique mark. I cannot be more excited for you as you take the step forward to learn this timeless craft. Amid the fast-paced, digital society we live in today, learning calligraphy will enable you to create something with your hands that is personal, meaningful, and irreplaceable. May this book help deepen your appreciation and love for handwritten words.

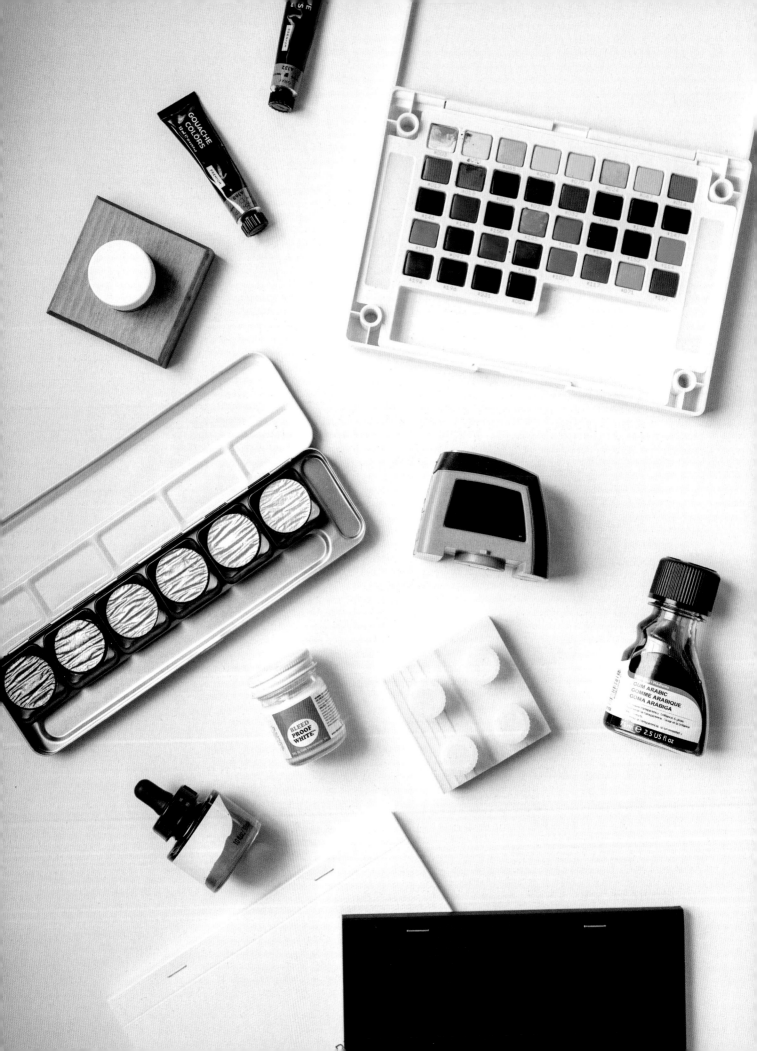

1

Getting Started

Setting up properly with the right tools and materials will greatly enhance your whole writing experience. After taking my first pointed pen calligraphy workshop, I remember feeling overwhelmed walking through the art supply stores and scrolling on Amazon. Thankfully, I've learned from my mistakes over the years, and I am excited to share some of my favorite supplies and recommendations so you can get started on the right track.

Recommended Tools and Materials

Paper

Choosing the right paper is crucial to preventing ink from bleeding through the paper or feathering, which is when your lines spread out from the edges and become blurred. For practice, I print my guide sheets directly on HP Premium 32. Thicker than regular copy paper, it is smooth, takes ink well, and is cost efficient. You can also place a guide sheet behind a translucent paper such as Canson Pro Layout Marker Pad, Borden & Riley #37, or Borden & Riley Cotton-Comp Marker Pad. Rhodia graph notepads are also nice to write on, but I recommend drawing in your slant lines or placing a slant guide sheet behind it.

For finished pieces, I use thicker paper, such as cover card stock or watercolor paper, so that it doesn't warp. Canson XL cold-pressed watercolor paper is one of my favorite kinds of paper to write on and has a bit of texture to it. If you prefer writing on a smoother surface, you can try Canson or Strathmore Bristol paper. Hot-pressed watercolor paper will also give you a smooth surface to write on. Always make sure to test your ink on your paper before working on your final piece.

HANDMADE PAPER

If you love rough or deckled edges, you will love writing on handmade paper! There are many wonderful papermakers that offer them in a variety of sizes and colors. Some of my favorite shops include SHare Studios, Inquisited, and Fabulous Fancy Pants. If you find that your ink is bleeding, try spraying a fixative over the paper or write with gouache instead.

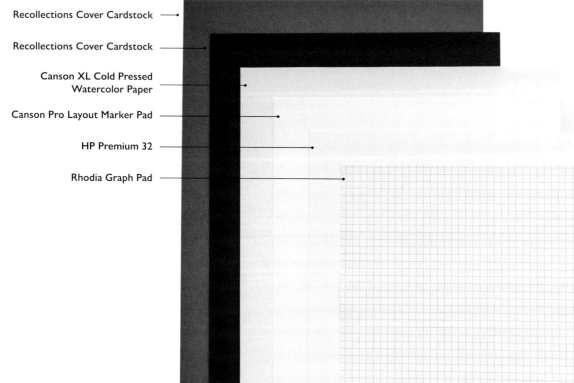

Recollections Cover Cardstock
Recollections Cover Cardstock
Canson XL Cold Pressed Watercolor Paper
Canson Pro Layout Marker Pad
HP Premium 32
Rhodia Graph Pad

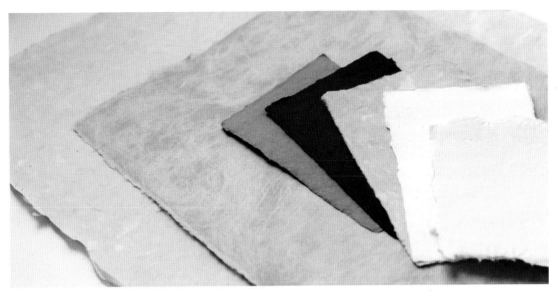

A range of papers can be used for calligraphy: mass-produced papers (*opposite*) and handmade (*above*).

Nib

A nib refers to the point of the pen. Though pen nibs come in many different shapes and sizes, we can categorize them into two main groups: broad edge and pointed. Broad-edge nibs are rigid, flat at the top, and used for scripts such as Italic, uncial, and blackletter. Pointed nibs are flexible and come to a sharp tip. For this book, we use pointed nibs to write Copperplate and Spencerian.

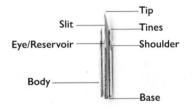

NIB ANATOMY

The top of your nib is called your **tip**. The **slit** is what separates the tip into two **tines** (left tine and right tine). Sometimes there are manufacturer defects, so make sure there's no space between the tines and that your tines are not bent. You always want to handle the tip of your nib with care. The **eye/reservoir** is what helps with the ink flow. When you dip the nib into the ink, you want to make sure the ink is fully covering the eye of the nib. Next, you have the **body** and the **base**. To prevent damaging the tip of your nib, you want to hold the nib along the body when inserting it into your penholder. You can also find the name of the nib imprinted on the body.

Exerting and releasing pressure is what separates the two sides of the nib (called tines) to create shades (thick strokes) and hairlines (thin strokes).

NIB CHOICE

The level of sharpness and flexibility of your nib point are important elements to consider when choosing your nib. Nibs such as Nikko G, Zebra G, and Brause 361 have a sturdier tip, which makes them beginner friendly because they are easier to control. Gillott 404, Hunt 22B, and Leonardt Principal EF have more of a medium flex with a sharper tip. Then you have a nib such as Hunt 101 that's really flexible and may be difficult to write with if you're just starting off.

Because some of us are naturally light handed and others are heavy handed, I recommend trying a variety of nibs to see what works best for you. You can find sampler nib sets at John Neal Books and Paper & Ink Arts, as well as in my shop.

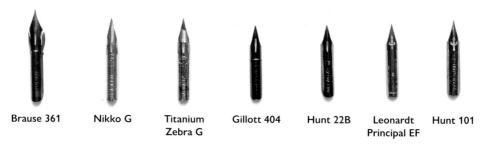

Brause 361 Nikko G Titanium Gillott 404 Hunt 22B Leonardt Hunt 101
 Zebra G Principal EF

Penholder

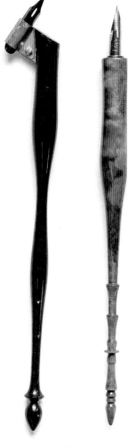

Penholders: oblique (*left*) and straight (*right*).

There are two kinds of penholders: oblique and straight. The difference is that the oblique has a metal flange that will help you to write at a consistent angle. *Note:* As a left hander, I spent the first year writing with a straight holder before switching to an oblique holder. I personally find that the oblique holder helps keep both tines equally on the paper at an optimal angle. Switching to an oblique also helped improve my upstrokes and flourishing. I use a right oblique holder, not the left oblique.

If you want to try both options, there are inexpensive penholders called the "Deuce" Penholder by Yoke Pen Co. or Moblique that you can purchase at Paper & Ink Arts or John Neal Books. These holders will allow you to remove the flange and use it as a straight.

I want to mention that the flange on the oblique holders will initially be fitted to certain nibs. For example, a flange that is fitted for Nikko G nib or similar nib may not fit a smaller nib such as Brause 66EF. In that case, depending on the flange, you can use pliers to pinch the sides of the flange or use your fingers to gently adjust its curvature. If you feel uncomfortable adjusting the flange yourself, I highly recommend getting a holder with a screw flange. The screw will hold your nibs in place, no matter how small or big they are.

There are many holders available now, from plastic, wood, and resin to a one-of-a-kind custom-made turned penholders, which are more expensive. Over the years, I've collected penholders from Jake Weidmann, Heather Held, Dao Huy Hoang, Ink Slinger Pens, Calligraphica Shop, Michael Sull, Yoke Pen Co., and Luis Creations. I love how each one is unique, and I enjoy writing with them.

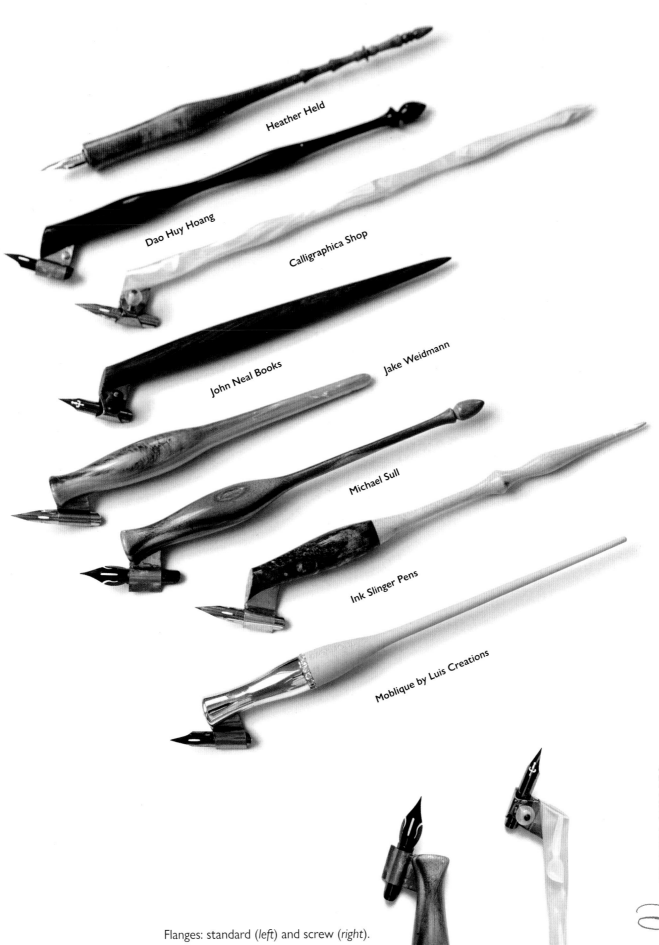

Heather Held

Dao Huy Hoang

Calligraphica Shop

John Neal Books

Jake Weidmann

Michael Sull

Ink Slinger Pens

Moblique by Luis Creations

Flanges: standard (*left*) and screw (*right*).

Ink

When it comes to ink, you want to make sure the ink will not feather or bleed on your paper. For black, my favorite is the Moon Palace Sumi ink. It is opaque and has a slight sheen to it. The Kuretake Sumi ink is also a good one to practice with. *Note:* The ink may thicken if you leave the ink jar open for a long time. To help with ink flow, add a couple drops of distilled water into your ink, mix, and try again. Another ink that is great to practice with is Tom Norton's walnut ink. It is ready to use right out of the bottle, has a rich sepia tone, and flows really well off the nib. This ink will give you great hairlines.

For white ink, I highly recommend Dr. Ph. Martin's Bleedproof White. It comes in a bottle and will look like a thick paste. You will need to mix it with water until it reaches a milky consistency. Test the opacity by adding more water or paste until the ink flows smoothly from your nib. Instead of mixing it in the bottle, I like to transfer the paste into small ink jars called dinky dips and then add drops of water into it. The dinky dips are a perfect size for the nibs, and you can purchase a wooden base to hold them in place.

Gouache Paint and Acrylic Ink

If you wish to write with colored ink, you can make your own ink using gouache paint. Gouache can be diluted, dries matte, and mixes well with other gouache colors, so the possibilities are endless! It is sometimes referred to as "opaque watercolor" because the ratio of color pigment is higher in this medium versus watercolor. Gouache colors come in small tubes that you can buy individually or in sets. To make your own ink using gouache, first squeeze the paint into a small ink jar, and then add distilled water and mix. The amount of paint needed will depend on the size of the jar, but generally, I will fill it up at least halfway before adding water.

I recommend purchasing a high-quality gouache such as Winsor & Newton, Schmincke, or Arteza because it will produce color that is bright and opaque. If your ink smears even after it is fully dried, you can add drops of the binding agent gum arabic into the ink, mix, and try again.

Acrylic ink can also be used for calligraphy. It's different from gouache in that it can have a matte, satin, or glossy finish and is water resistant when dried. I personally enjoy writing with Ziller Ink and Amsterdam Acrylic Inks.

Watercolor

If you like the transparent look or wish to create an ombré effect with your letters, watercolor would be the medium to use. When you purchase these paints in tubes, you will have to add distilled water to bring them to the right consistency. Another great option is to use ready-made watercolor in liquid form such as the Ecoline liquid watercolor. They come in sixty different colors, and the 30 milliliter glass bottles come with a pipette that you can use to apply the watercolor onto the front and back of the nib. When I'm traveling or on the go, I also love packing my Sakura Koi Water Color Field Sketch Kit or Watercolor Confections by Art Philosophy Inc. They are both portable and come in a palette set of various colors.

Metallics

To add a beautiful shimmer and shine to my work, I love using Finetec metallics. They are made of high-quality raw materials and mica pigments and are offered in various pearlescent colors. For calligraphy, add a couple drops of distilled water onto the color pan, mix with a paintbrush, and apply it on the front and back of your nib.

Another popular option is the Pearl Ex Pigments. They come in powder form and can be mixed with water and gum arabic to make calligraphy ink. You can also add a bit of Pearl Ex directly into other inks to make them shine. The basic recipe that I've learned from Joi Hunt of Bien Fait Calligraphy is to mix four parts pigment with one part gum arabic and add distilled water until you reach the kind of consistency you want for ink. Adding more water will cause the pigment to lie flatter on your paper, whereas a thicker consistency will give the ink a raised look after it dries.

Brush and Brush Pen

When you want to write in a larger scale, knowing how to write with a paintbrush or brush pen will come in handy. You will use a paintbrush to pick up pigment from various inks, whereas brush pens already come in different colors.

For paintbrushes, I enjoy using the Princeton Velvetouch 3950 series or the Princeton 4350 series in their round brush sizes. Depending on how small or big I need to write, I will use a 2/0 brush up to a size 6 or 8. Water brushes are also a popular option to use for calligraphy. They come with a barrel to store your water. I personally don't use the water barrel as I'm writing, but I do like how the water brush is easy to control and smooth to write with. Pentel Aquash or Sakura Koi water brushes are nice to write with and are available in small, medium, and large sizes.

Brush pens can also be categorized by the size of the tip. To mimic the delicacy of a nib, I like to practice with a fine tip brush pen such as Pentel Sign Pen Brush, Kelly Creates Small Brush Pen, or Tombow Fudenosuke Brush Pen. Other brush pens with a medium-size tip that I recommend include Ecoline Brush Pens, Tombow Dual Brush Pens, Kuretake Zig Brushables, Sharpie Brush Pens, and Cedar Markers.

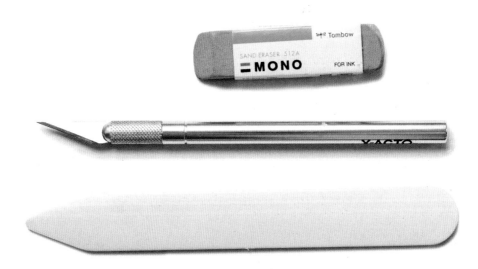

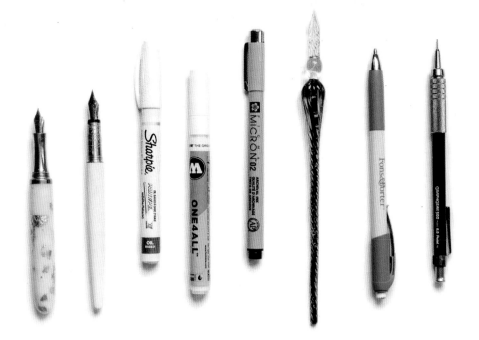

Pen and Pencil

There may be times when you are writing on a non-traditional surface such as wood or glass that is not conducive to nibs or brushes. That's when we will be doing faux calligraphy, which means we will be imitating the look of calligraphy using any writing tool, even a pencil. I especially love using a pencil for faux calligraphy when sketching out designs.

Some of my favorite pens and pencils are:

- Micron Pens by Sakura of America
- Sharpie Oil-Based Paint Marker
- Molotow Acrylic Paint Marker
- Glass Pen
- Fons & Porter 7757 Mechanical White Pencil
- Pentel GraphGear 0.5 mm Mechanical Pencil

Other Helpful Supplies

- **Light pad.** This is great to use when writing on light colored paper or envelopes. You can place your final paper on top of your guide sheet or sketch. I have the Treviewer Light Pad, but I also recommend the Huion A3 or the Artograph A3. The size is perfect for various projects, and it's an investment that has lasted me for years.
- **Laser level.** When you are writing on dark colored paper, this will be an essential tool for you. I recommend getting a Black & Decker Laser Level. It's a portable and inexpensive tool that I use all the time, and it helps me write in a straight line. Just place your paper on top of your guide sheet and use the laser level to mark your baseline.
- **X-Acto knife, Tombow sand eraser, and bone folder.** This combination is what I use to fix calligraphy spelling errors. I use the X-Acto knife to lightly scrape off the mistake from my paper, use the sand eraser to get the rest of the ink off, and then smooth down the paper using a bone folder. You can also spray your paper with a bit of hair spray to prevent ink from bleeding when you re-write your letter.

Preparing to Write

Prepping the Nib

A brand-new nib comes with a protective coating to help prevent it from rusting. However, the coating will repel the ink, which will cause droplets to form on your nib. This will affect ink flow as you write. Therefore, it's important to prep the nib before using it.

There are several ways to remove the coating. You can wipe each side of the nib with an alcohol wipe, rub it gently with toothpaste, use your saliva, or if you need to prep many nibs at once, use a small uncooked potato! The starch in the potato will help break down the coating and allow the ink to adhere properly onto the nib.

If you are using the potato method, make sure you insert the nib at a lower angle with the curved part facing up. Insert the nib until the potato covers the eye of the nib and leave it in for a couple of minutes. Wipe the nib down with distilled water and then dip it into your ink until the eye of the nib is covered. If your nib is prepped correctly, the ink should coat the nib evenly.

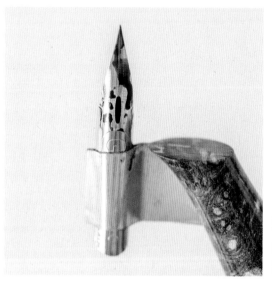 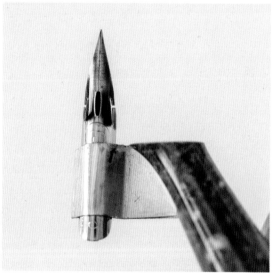

An unprepped nib (*left*) and a prepped nib (*right*).

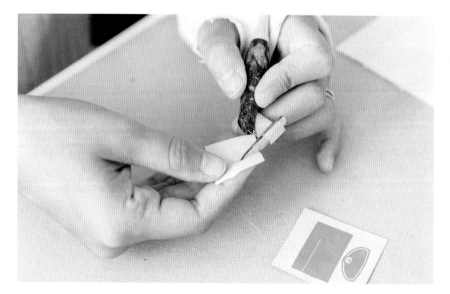

Wiping a new nib with an alcohol wipe to remove the protective coating.

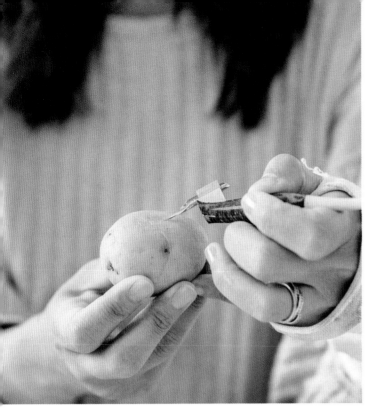

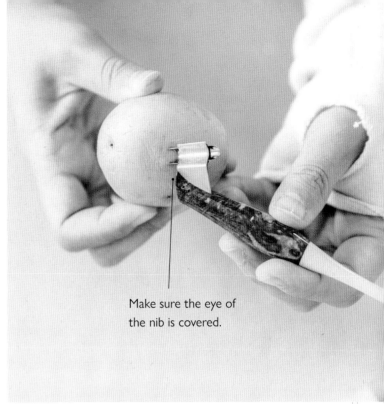

Make sure the eye of the nib is covered.

When using a potato to prep a nib, insert the nib into the potato at a lower angle with the curved part facing up.

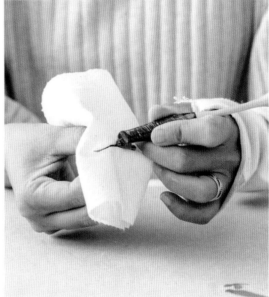

Cleaning the Nib

When you are done with your nib or need to take a longer break, make sure to wipe the ink off your nib right away. If the ink dries on your nib, it will affect your ink flow. I usually keep a small dropper bottle of distilled water on my desk and use a smooth paper towel to wipe down the front and back of my nib. Viva is cloth-like and doesn't have fibers that can get caught in the tines of the nib. You can also use a cotton rag if you don't have access to Viva paper towels.

Inserting the Nib into the Holder

You are now ready to insert the nib into your holder.

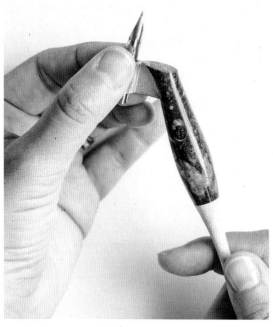

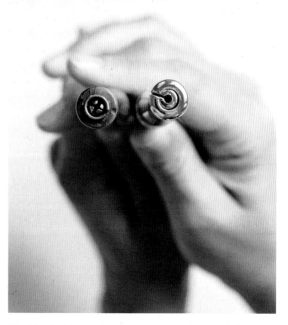

If you're writing with a right oblique pen, the flange will be on the left, and you will insert the nib with the curved part facing down. Be careful not to touch the tip. Rather, handle the nib carefully by the body.

Straight holders will have either an inner circle or inner prongs that will hold the nib in place.

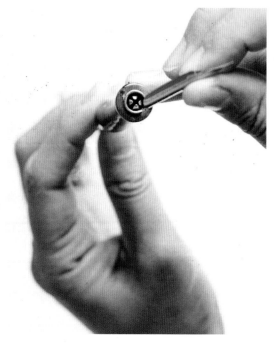

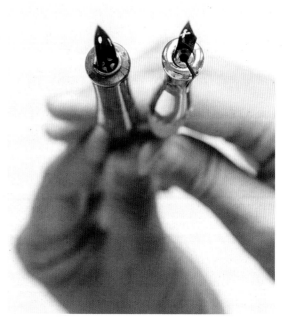

Insert the nib just far enough . . .

. . . so that it will be secure.

Nib Alignment

When you insert the nib into an oblique pen, there are two things you want to take note of. First, make sure the tip of the nib aligns to the middle of the holder. If it is not properly aligned, it will affect the angle of your nib to the paper. I have also noticed that with some penholders, the flange places the nib on an outward cant, which will cause frustration, as the tines are not resting evenly on the paper. In that case, you can adjust your flange so that the nib will have a slightly inward cant.

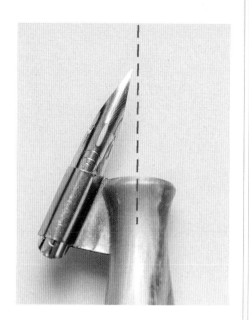

Posture and Set Up

As you sit down to write, relax your shoulders, keep both feet on the ground, and try not to slouch or hover over your letters as you write. Often times, because of our nerves, we end up tensing up and using a death grip on our holder, which will lead to muscle and hand fatigue. If you need to write for a long time, remember to take breaks to stretch and loosen up.

How do you hold the pen? Traditionally, the pen is held with a dynamic tripod grip, which means that you will grasp the pen with your thumb and index finger and rest it along the side of your middle finger. The ring finger and pinky finger will be curled into your hand to provide stability, and you will be gliding along the side of your hand and pinky finger as you write. There are other pen holds such as the dynamic quadrupod, lateral tripod, or lateral quadrupod; however, they may limit your finger movement and effectiveness when writing.

If you are left-handed using a right oblique pen, your index finger will rest right above the flange. If you are right-handed, your thumb will rest right behind the flange or barely touch it. Some will hold the pen right up at the top, while others will prefer holding the pen farther back behind the flange. That is all personal preference, but I find that holding the pen closer to the top will give you better control. I like to hold the pen anywhere from 0.5 cm to 0.8 cm from the top.

As you hold the pen, anchor your writing arm to the edge of your desk on your forearm muscle, which is located right below your elbow. For both Copperplate and Spencerian, we will be using combined movement, which is movement from our fingers, wrist, and forearm. Whole-arm movement is when the movement is coming from our shoulder, and I usually use this when I am writing big letters or flourishes.

You also want to be mindful of your **writing space,** otherwise known as your "sweet spot." Make a circle in front of you with both your hands and bring it down to your desk. Ideally, we want to keep our paper in that sweet spot. If we extend too far out or come too close to our body, it will affect the quality of our writing.

Paper Position

There is no "right" way to position your paper as it varies depending on your individual hand position and grip. However, here are some general guides that you can start with. Traditionally, when you are using a straight holder, whether you are left-handed or right-handed, the paper is angled at about 45 degrees. The bottom corner of the paper is pointed toward your body. When you are using an oblique penholder, that angle can be anywhere from 45 to 90 degrees. As I tell my students, place your arms on the desk first while holding the pen comfortably. Then, slip a guide sheet underneath your writing hand and adjust the paper until the slant line runs parallel to the eye of the nib. Don't adjust your writing hand to the paper. Rather, adjust the paper to your writing hand.

As a lefty, I like to angle my paper about 90 degrees to the right. Because my wrist is under the baseline, this paper orientation allows me to see my letters clearly and prevent ink from smearing. It took a bit of time to get used to writing letters toward my body, but seeing letters as individual strokes helped me adapt to this paper angle.

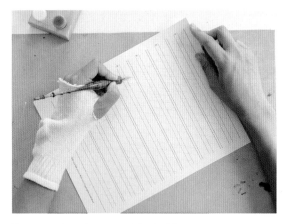

Paper angle using a straight holder as a left-handed person.

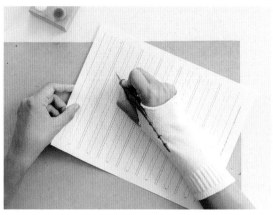

Paper angle using a straight holder as a right-handed person.

Paper angle using a right oblique holder as a left-handed person.

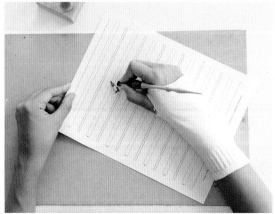

Paper angle using a right oblique holder as a right-handed person.

Troubleshooting

Over the years, I've come across common questions asked by my students that I want to address here. As you may encounter similar issues, I hope this section is helpful for you.

My nib keeps catching on the paper and it sounds scratchy.
Depending on what nib you are using, the level of scratchy sound will vary. Nibs that have a sharper tip will sound scratchier than sturdier tips. Try to keep a light hand and write slowly. If your nib keeps catching on paper, oftentimes, it is because the nib angle is too high. Slowly lower the angle of the nib to the paper and see if that helps prevent catching on the paper.

All my strokes are thick. There's no difference between my hairline and shade.
First, check to make sure that there are no paper fibers stuck between the tines of your nib. Even the smallest dust can cause thicker strokes. Then, slowly increase the nib angle so that it's held at about 45 degrees from your paper.

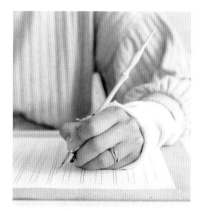

The nib at an optimal angle to paper, around 45 degrees.

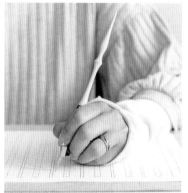

If the nib angle is too high, it may cause your nib to snag.

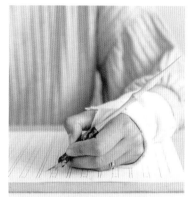

If the nib angle is too low, your lines may come out thicker.

Why are my lines so shaky? I can't seem to write in smooth, clean lines.
If you are just starting out and your lines are shaky, that is completely normal. Learning and getting comfortable writing in calligraphy will take time. Focus on the letterforms, and as you continue to practice and gain confidence, the shaky lines will get better.

My ink is not flowing out of my nib.
Sometimes when we leave the ink jar open for a long period of time, the ink will evaporate and thicken. In that case, I add a couple drops of distilled water into the ink, mix, and try again. If the nib is prepped and the ink consistency is good, the ink should flow from your nib effortlessly. To do a quick test, scribble on the side of the paper to check for ink flow.

A B C D E F G
H I J K L M N O
P Q R S T U V
W X Y Z

abcdefghijklmnopqrstu

2

Copperplate Script

Calligraphy means "beautiful writing," and personally, I think Copperplate is the most beautiful and versatile script out there. It holds a special place in my heart because it is what jumpstarted my whole creative journey. While browsing online for calligraphy classes back in 2014, I stumbled upon an advertisement for a local Copperplate workshop and was immediately captivated by the elegance and beauty of this script.

Though some may find traditional calligraphy to be intimidating, I love teaching this script because it can easily be broken down into tangible steps. In this chapter, I will walk you through the basics from using guidelines to learning basic strokes, and then we will look at the lowercase and uppercase letterforms together. I hope you will fall in love with this script as much as I did. Let's begin!

Introduction to Copperplate

Copperplate calligraphy is derived from a form of handwriting called the English Round-hand, which was widely used from the sixteenth century and peaked in popularity by the nineteenth century. You can find many wonderful examples of Roundhand script in George Bickham's book *The Universal Penman*. The name *Copperplate* comes from its printing process, during which handwritten letters were engraved onto a single copper plate by a master engraver using a tool called a burin.

What's important to note is that English Roundhand was written using a narrow broad-edge quill pen, whereas Copperplate today is written with a pointed, flexible steel nib to achieve the thick shades and delicate hairlines. Each letter is written thoughtfully by combining various strokes together. Take a look at the difference between an English Roundhand sample versus my Copperplate script (below). More information regarding the history of Copperplate can be found on the International Association of Master Penmen, Engrosser's, and Teachers of Handwriting (IAMPETH) website.

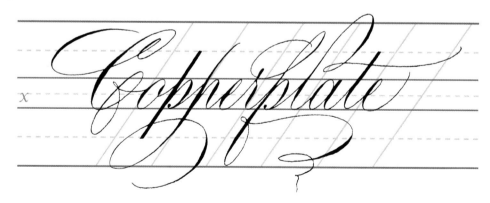

Writing sample from *The Universal Penman*, written by Joseph Champion, engraved by George Bickham, 1733.

A modern example of Copperplate script.

Using and Understanding Guidelines

Because Copperplate is a very structured script, it is important to use guidelines while you practice. The guidelines will not only help you make the right proportions for the letters, but they will help build up your muscle memory so you can write on a consistent slant. You can print them directly on your practice paper or place your guide sheet behind a translucent paper so that you can see the lines through it.

Let's go over the terminology that we will be using to learn this script.

- The **baseline** is where most of our lowercase and uppercase letters will sit. Practicing with a baseline will help keep our lines straight.

- The **waistline** (sometimes called a header) is the boundary line between the x-height and ascender space. For letters that contain ascenders or descenders, we will use this line as a reference point for starting some of our strokes.

- The **x-height** is the distance between the baseline and the waistline where the main body of the lowercase letter resides. It is usually marked with an "x" on the guide sheets. I've also included a dotted line to indicate the middle of our x-height.

- The **ascender space** is the area above the waistline. For Copperplate, there are two ascender lines. Lowercase letters such as d, t, and p will only go up to the first ascender line, while other letters such as b, f, h, k, and l will go higher to the second ascender line.

- The **descender space** is the area below the baseline. Similar to the ascender lines, there are two descender lines for this script. Letters f and p will stop at the first descender line, while other letters such as g, j, q, y, and z will go down to the second descender line.

- A **counter** is the space that is partially or completely enclosed within a letter. For this script, the counter will be in an oval shape and can be found in letters such as a, d, g, o, and q.

- The **slant line** for this script is generally at 55 degrees. Because our natural handwriting slant may be more upright, it is important to practice using this slant line to help guide your downstrokes.

Ratio and X-Height Variations

The ratio that we will be using in this book is 2:1:2, meaning that the height of the ascender and descender spaces are each double the x-height. However, there are other ratios you can try. The 3:2:3 ratio is another popular one where the height of your ascender and descender spaces are each one-and-a-half times the x-height. You can also keep each height the same with a 1:1:1 ratio. Depending on the ratio that you use, your letters will give off a different vibe. I personally like using the 2:1:2, but don't go all the way to the second ascender or descender line. Here's a look at all three ratios for comparison:

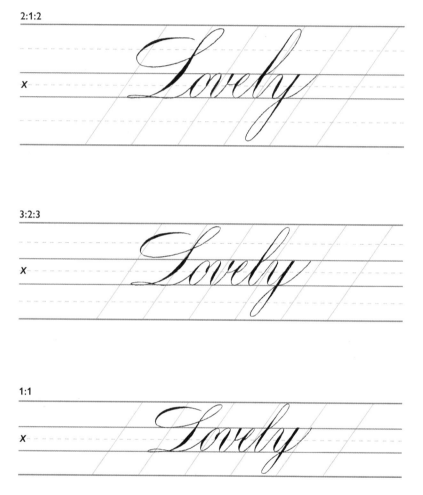

2:1:2

x

3:2:3

x

1:1

x

Warm-up Exercises and Nib Exercises

Warm-up Exercises

Let's begin with some warm-up exercises. As with any sport or activity, we want to prepare our body and mind before we write. You can start with a pencil first and then move onto nib and ink. Our goal through these exercises is to build muscle memory and work toward having a light hand. Keep a light grip on your penholder and glide along the side of your hand. Feel free to turn on light background music as you do the following:

1. DIRECT AND INDIRECT OVALS

- Begin by making continual oval shapes from your baseline to your second ascender line across the paper. Try going in both a clockwise (indirect) and counterclockwise (direct) motion.

- Next, slowly increase and then decrease the size of your oval as you move across the paper.

- Aim to keep your oval shapes at the 55-degree slant.

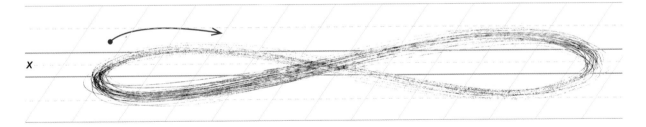

2. FIGURE 8s

- For this exercise, we will be using our whole-arm movement. Your forearm muscle is not anchored, and you will be gliding along the side of your hand.

- Utilize the entire width of your paper and aim to make narrow oval shapes.

Nib Exercises

Next, we want to take some time to study the flexibility of your nib. The reason why I love doing these nib exercises is because each nib is made differently and can produce varying shade and hairline strokes. In addition, we all have unique hands. Some calligraphers have a light hand and others have a heavier hand. It's important to experiment and see what nib feels comfortable to you. For all the nib exercises, we will begin at the second ascender line and end at the baseline. Take your time and make sure all your strokes are running parallel to the slant line.

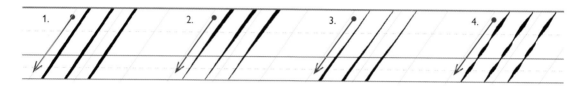

1. **Full Pressure Stroke.** Start and finish with a squared top/bottom. Aim to maintain equal width throughout the entire stroke.

2. **Thick/Thin Stroke.** Start with full pressure and gradually lighten the pressure as you move toward the baseline.

3. **Thin/Thick Stroke.** Begin with a hairline, no-pressure stroke and gradually add pressure as you move toward the baseline.

4. **Running Beads.** This time, you will be doing quick pressures and releases as you move down the slant line. Take note of how much pressure you have to exert to separate the tines.

Lowercase Basic Strokes

There are seven basic strokes that are the building blocks to Copperplate lowercase letters. For example, lowercase *a* is written in three strokes:

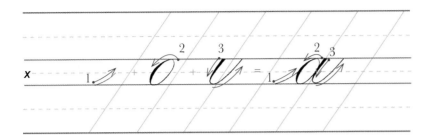

Mastering the following strokes will enable you to write with consistency and rhythm. Let's take a look at each of the basic strokes.

1. **Entrance/Exit Stroke.** This is a hairline upstroke with a slight curve from the baseline to the waistline. We will use this stroke to begin and end our letters.

2. **Overturn.** Begin with a hairline upstroke and gradually add pressure after you make a curve from the waistline to baseline. The shade should run parallel to the slant line.

3. **Underturn.** Begin with a squared top and gradually release pressure before you hit the baseline and curve back up toward the waistline.

4. **Compound Curve.** This is a combination of your overturn and underturn strokes. Make sure the shade is on the slant line and that the area left and right of the shade is equal in width.

5. **Oval.** You can begin this stroke either at the waistline or at the 1 o'clock mark. Gradually add and release pressure as you make this stroke so that the thickest part of the shade lies at the middle of your x-height.

6. **Ascending Stem Loop.** Start this stroke at the waistline and gradually add pressure after you make the curve and go down toward the baseline. Finish with a squared bottom.

7. **Descending Stem Loop.** Begin with a squared top at the waistline and gradually release pressure as you move toward the second descender line. The shape of this loop is similar to the ascending stem loop.

How to Square Tops and Bottoms

There are several ways to achieve letters with squared tops and bottoms.

As you move your left tine over, you will notice that your right tine will naturally go down and create a small triangle on the top.

Continue to go down along the slant line toward the baseline.

For squared bottoms, gradually increase pressure as you go down to the baseline.

At the baseline, move your right tine over to meet the left tine and then pick up your pen.

1. **Draw.** After the hairline upstroke, draw a small line across to the right and then add pressure so that the left tine will move to the left to fill up the space. Then move your nib down along the slant line.

2. **Tine Manipulation.** This method is similar to the first one, except you will begin by anchoring your right tine and add pressure to move your left tine over to the left. First, practice without ink to observe the way the tines of your nibs move. Then, practice using ink.

3. **Touch Up.** After you make your strokes, you can always go back and clean up your lines to make those nice squared tops and bottoms. There is nothing wrong with touching up your lines.

Lowercase Letters by Group

We can break lowercase letters down into four groups by the common strokes that they share. Visualizing the letters in smaller groups will help you practice with intention and find rhythm as you write.

Group 1

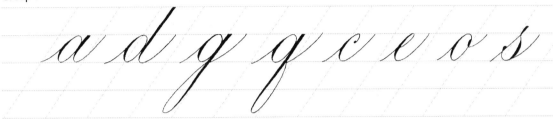

Group 2

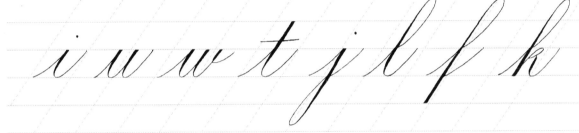

Group 3

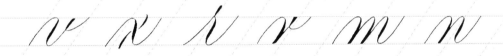

Group 4

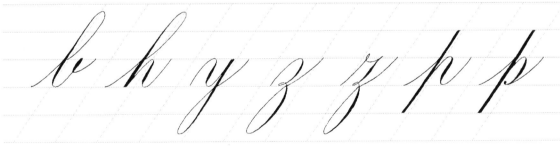

1. **Group 1.** Letters that contain the oval shape, both direct and implied.

2. **Group 2.** Letters with underturn strokes, squared tops, and ascending stem loops.

3. **Group 3.** Letters with overturn and compound curve strokes.

4. **Group 4.** Letters that contain ascending and/or descending stem loops, compound curve stroke, and an indirect oval shape.

Lowercase Letters Exemplar

Below is a lowercase letters exemplar with instructional number guides to show you how to make each letterform. After completing the first stroke, pick up your pen before moving on to the next number. Feel free to put a translucent paper on top of this page to trace these letters first before writing them on your own. For further practice, you can find digital downloadable practice workbooks in my shop.

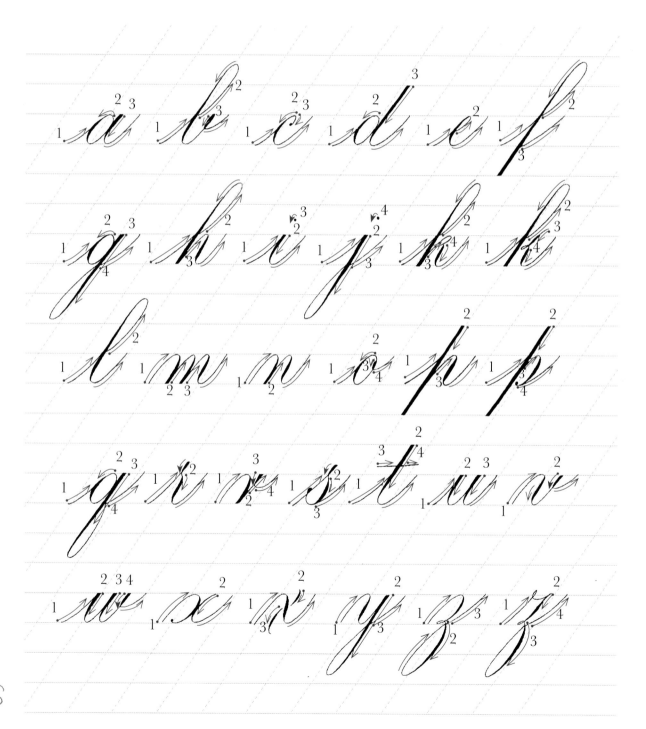

Connecting Letters

Just as we do for our individual letters, when we connect Copperplate letters together, it is important to lift the pen after every stroke. Let's take a look at the word *connecting*. To write this ten-letter word, there are actually sixteen different strokes (not including dotting the *i* and crossing the *t*).

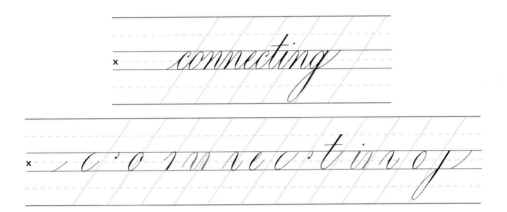

Notice that for some connections, such as *n-n* and *i-n*, there will be a longer connective stroke (see colored strokes above). If a space is defined as one unit wide, then in the longer connective strokes, we want to tighten the spacing so that it will be about one-and-a-half units wide. This will help with the visual spacing so that the letters will not be too far apart.

Generally, there are two things to keep in mind when connecting letters:

- **The exit stroke of one letter will become the entrance stroke of the next letter.** Let's take a look at an example of connecting *a* and *i* below. The full exit stroke of *a* will go right into the full entrance stroke of *i*.

- **Keep the next letter in mind as you write.** This will help with the flow of your writing. If we look at the example of the connection between *a* and *o* below, because the entrance stroke of *o* stops at the middle of the x-height, we want to adjust the exit stroke of *a* so that it also stops at the middle of the x-height.

Tip

Make sure to keep the angle of the entrance and exit strokes consistent throughout your word. This will help maintain even spacing between your letters.

The following are common digraphs, otherwise known as ligature connections. Digraphs are two letter combinations that make up one sound such as *br*, *ch*, *ee*, *re*, and *sk*. Some connections may be trickier depending on the exit and entrance strokes. Pay attention to each of the pairs, especially letters such as *b*, *o*, *w*, *x*. Begin practicing with these digraphs until you get comfortable with connecting the strokes before writing out words.

ao ai ay ab br

bl cl ch ee ea

fr ie ng ot oo

on os ph re ro

sh sc sk tw ue

wr wo wx ze zi

Uppercase Basic Strokes

Similar to the strokes that make up our lowercase letters, the following strokes are the building blocks to our uppercase letters. Take the time to practice these strokes before moving on to the letters.

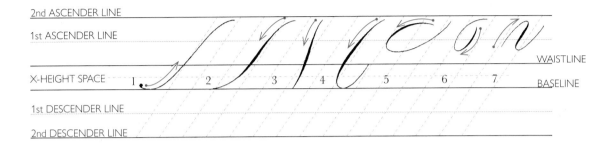

1. **Hairline Entrance Stroke.** Start with a dot at the baseline and slightly curve toward the second ascender line. This should be a hairline stroke with no pressure.

2. **"S" Curve.** This is also known as the universal line of beauty. The shade lies parallel to the slant line and begins and/or ends with a thin stroke.

3. **Upright Curved Line.** This stroke is almost perpendicular to the baseline. We will use this stroke for letters such as *N*.

4. **"C" Curve.** Keep a slight oval shape. We will use this stroke in letters such as *M* and *H*.

5-7. **Entrance Strokes.** These three strokes are various ways we will be entering into an uppercase letter.

Uppercase Letters by Group

We can break the uppercase letters down into seven groups by the common strokes that they share. Visualizing the letters in smaller groups will help you practice with intention and find rhythm as you write.

Group 1

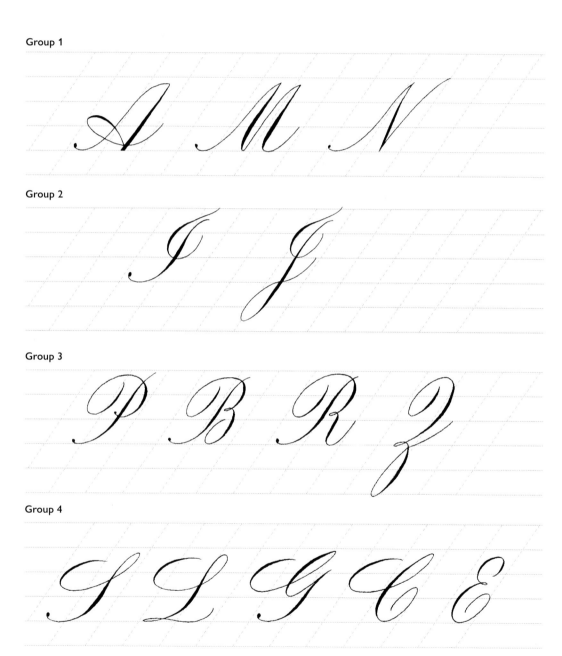

Group 2

Group 3

Group 4

Group 5

Group 6

Group 7

- **Group 1.** Letters *A*, *M*, and *N* all begin with a hairline entrance stroke.

- **Group 2.** Letters *I* and *J* contain the capital stem stroke as well as the curved stroke on top.

- **Group 3.** These letters contain the indirect oval stroke.

- **Group 4.** Letters *S*, *L*, *G*, and *C* all begin with a horizontal oval entrance stroke. Letter *E* does not contain this stroke, but you can use the horizontal oval entrance stroke when flourishing this capital letter.

- **Group 5.** Letters that contain the indirect oval shape and letters *T*, *F*, and *Y* contain the capital stem stroke.

- **Group 6.** These letters all begin with the compound curve entrance stroke.

- **Group 7.** Letters *O*, *Q*, and *D* contain the direct oval shape.

Uppercase Letters Exemplar

Below is an uppercase letters exemplar with instructional number guides to show you how to make each letterform. Remember to pick up your pen after each number. Feel free to put a translucent paper on top of this page to trace these letters first before doing them on your own. For further practice, you can find digital downloadable practice workbooks in my shop.

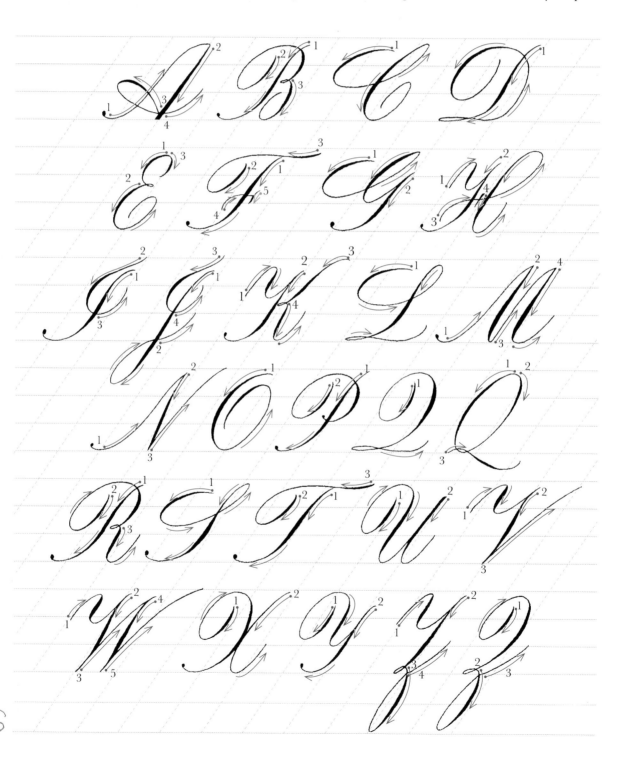

Nunca es tarde
para aprender

Qui n'avance pas, recule

You can't use up creativity.
The more you use,
the more you have

Maya Angelou

Spencerian Script

A B C D E
E F G H J J
E K L M N S
O P R S
O P T U V X
Y Y Z J

abcdefghijklmnopqrstuvwxyz

3

Spencerian Script

Spencerian is a delicate script that I find to be romantic and airy. I love the wispy hairlines and the subtle but dramatic shades of the capital letters. When I look at Spencerian letters, they look like they are dancing on paper.

Unlike Copperplate script, Spencerian is more of an angular script, written with fewer pen lifts and more fluid, rapid strokes. One way to distinguish between the scripts is by looking at the lowercase letters. Spencerian lowercase letters are delicately written with barely any shades. Though the scripts are different, I personally find that Copperplate and Spencerian complement each other wonderfully!

Introduction to Spencerian

Platt Rogers Spencer (November 7, 1800–May 16, 1864) developed Spencerian script, a form of penmanship that grew in popularity during the nineteenth and early twentieth centuries. He was passionate about handwriting from the time he was a young boy; however, because paper was a luxury at the time, he resorted to materials he could find in nature (tree bark, ice, sand, snow, etc.) and his environment became his inspiration for his beautiful and graceful letters.

James A. Garfield shared this with the students of the Spencerian Business College of Washington, D.C., in 1869:

> "Platt R. Spencer, studying the lines of beauty as drawn by the hand of nature, wrought out that system of penmanship which is now the pride of our country and the model of our schools." —New Spencerian Compendium, XVIII

Spencer taught his first writing class at the age of fifteen and spent the rest of his life teaching, sharing, and promoting this exquisite penmanship that we see today.

Copperplate

Spencerian

To help illustrate the differences between Copperplate (*top*) and Spencerian (*bottom*), I've written out *L'amore vince sempre*—"Love conquers all" in Italian—in both scripts.

Using and Understanding Guidelines

For Spencerian, we will use a similar guide sheet as Copperplate with a ratio of 2:1:2. However, the lettering slant line is at 52 degrees with a connective slant at 30 degrees. Some letters will only occupy the space between the baseline and waistline, while other letters will be longer in height and touch the second ascender and descender lines.

Make sure to use guidelines while you practice. The guidelines will not only help you create the right proportions for the letters; they will help build up your muscle memory so you can write on a consistent slant. You can print the guidelines directly on your practice paper or place them behind a translucent paper so that you can see the lines through it as you write.

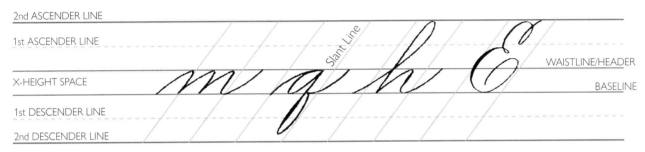

2nd ASCENDER LINE

1st ASCENDER LINE

WAISTLINE/HEADER

X-HEIGHT SPACE

BASELINE

1st DESCENDER LINE

2nd DESCENDER LINE

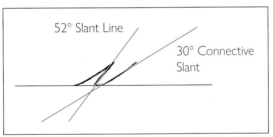

52° Slant Line

30° Connective Slant

Warm-up Exercises

Because Spencerian is also based on an oval shape, you can continue to do the warm-up exercises covered in the previous chapter. In addition to those, it will be helpful to practice visual spacing with the cross-drill exercises.

1. First, write out one line of practice letters. You can practice with one letter or connect different letters together. Continue to write the next line of practice letters right underneath the first line.

2. After you finish a couple of practice rows, turn your paper 90 degrees and write the next series of practice letters.

3. When you are done, you should see square boxes formed from the horizontal and vertical lines.

Lowercase Principles

There are five primary strokes, or principles, that make up our lowercase letters:

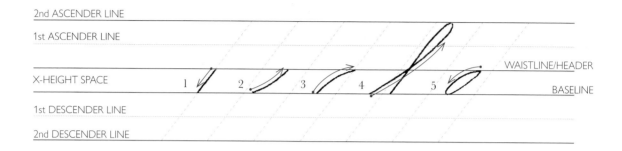

1. **Straight Line.** This is a hairline stroke that occupies the space between your baseline and waistline. The line will be on the 52 degree slant.

2. **Right Curve.** This is also known as an under-curve; the curve will be along the bottom.

3. **Left Curve.** Also known as an over-curve, this stroke curves along the top.

4. **Extended Loop.** Begin with an under-curve from the baseline to the second ascender line. Curve around to make a loop and go straight down on your slant line back to the baseline.

5. **Semi-Angular Oval.** This is a shape we will see in letters such as *a*, *d*, *g*, and *q*. It is not a complete oval shape as seen in our Copperplate letters, but a semi-angular oval, where the bottom will be more flattened. The top part of the oval is made by the over-curve, and the bottom part is formed by a nearly straight line.

Lowercase Letters by Group

We can also categorize Spencerian lowercase letters into three main groups.

Short Letters

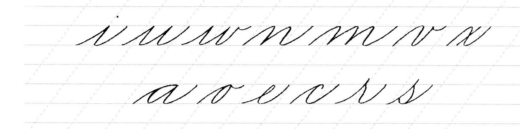

Semi-extended Letters

Extended and Loop Letters

1. **Short Letters.** These letters lie between the baseline and waistline. We can further categorize these letters into the following sub-categories:
 - *i*, *u*, *w*—These letters contain under-curves and straight lines.
 - *n*, *m*, *v*, and *x*—For these letters, we will combine over-curves, straight lines, and under-curves. These letters, with the exception of *x*, will be written with a continuous rhythm and stroke.
 - *a*, *o*, *e*, *c*—These letters contain over-curves, straight lines, and under-curves. The letters *a* and *o* also contain the semi-angular oval shape.
 - *r*, *s*—These letters begin with the under-curve stroke, but the first stroke will go a bit higher above the waistline.

2. **Semi-extended Letters.** The height of these letters is between the short and loop letters. The top of *t, d, p* will go up to the 1st ascender line. The bottom of *p* and *q* will go down between the first and second descender line.

3. **Extended/Loop Letters.** All of these letters contain the loop stroke.

Lowercase Letters Exemplar

Below is a lowercase letters exemplar with instructional number guides to show you how to make each letterform. Remember to pick up your pen after each number. Feel free to put a translucent paper on top of this page to trace these letters first before doing them on your own.

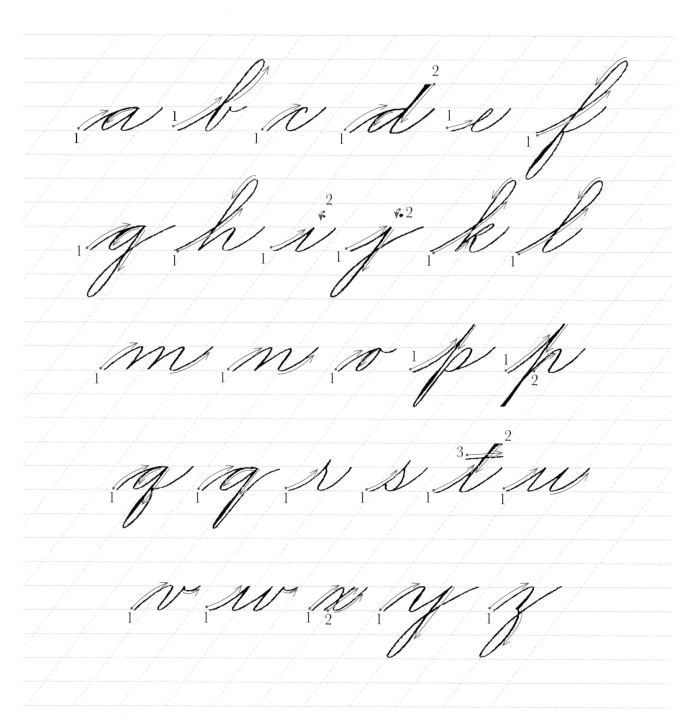

Uppercase Principles

For our uppercase letters, there are three main principles that we can see:

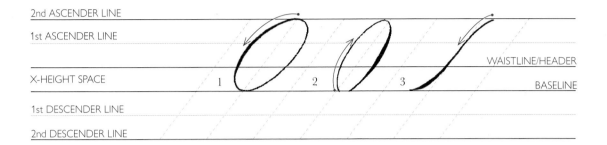

1. **Direct Oval.** Begin this stroke at the second ascender line and make an oval shape that is on the 52 degree slant line.

2. **Reverse Oval.** For this stroke, we will begin at the baseline and make a narrow oval shape along the slant line.

3. **Capital Stem.** This is an important stroke because it is used in many uppercase letters. Begin adding pressure at about the midpoint of this stroke. The thickest part of the shade should be along the bottom of the stroke as it flattens.

Uppercase Letters by Group

We can also categorize Spencerian uppercase letters into three main groups.

Direct Oval Capitals

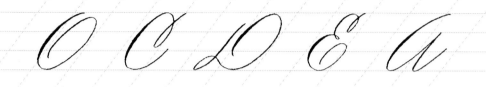

Reverse Oval Capitals

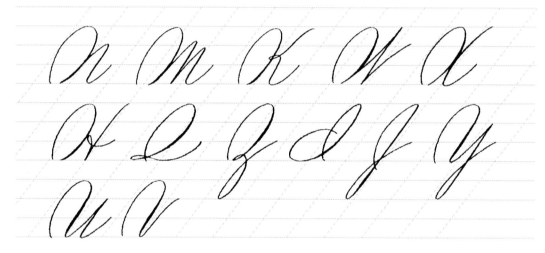

Stem Capitals

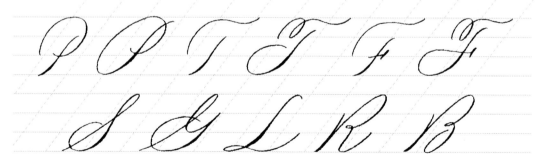

1. **Direct Oval Capitals.** Letters *O, C, D, E,* and *A* contain the direct oval shape in their letterforms. The oval is written in a counterclockwise direction.

2. **Reverse Oval Capitals.** These letters contain the reverse oval stroke, where the implied oval shape is written in a clockwise direction.

3. **Stem Capitals.** Letters *P, T, F, S, G, L, R,* and *B* contain the capital stem stroke.

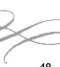

Uppercase Letters Exemplar

Below is an uppercase letters exemplar with instructional number guides to show you how to make each letterform. Remember to pick up your pen after each number. Feel free to put a translucent paper on top of this page to trace these letters first before doing them on your own.

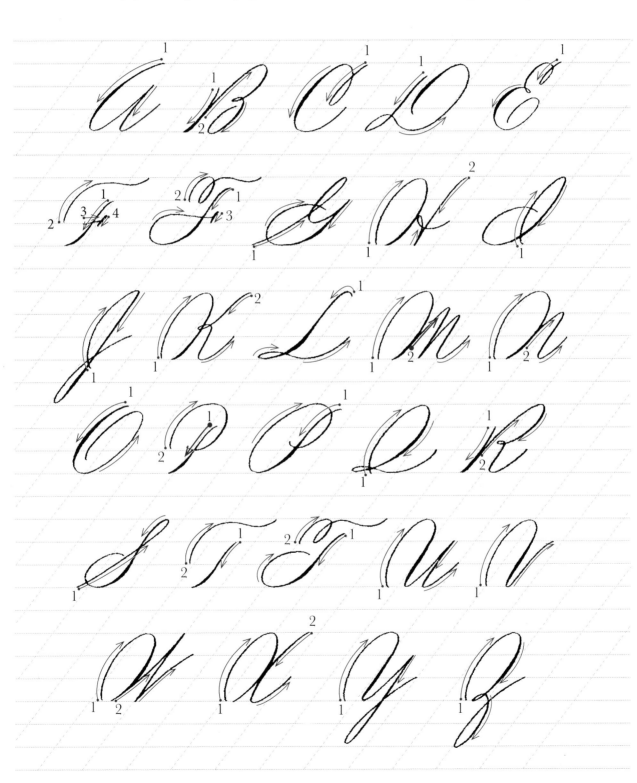

Serena Williams
Rancho Cienega Sports
5001 Rodeo Road
Los Angeles, California
90016

4

Flourishing and Other Techniques

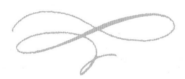

From the very beginning of my pointed pen journey, I fell in love with the concept of flourishing. Even before mastering the basics, I was impatient and eager to jump into flourishing letters. I was quickly humbled when I realized that flourishing is not something you can rush into overnight. So before we begin, I encourage you to take the time needed to focus on the basic letterform first before going into flourishing. Then, when you apply flourishes properly, they will take your letters to the next level.

In this chapter, I'm excited to break down the intimidation and fears you may have regarding flourishing into tangible methods so you can have a trained eye and be inspired to start flourishing with confidence!

We will also go over how you can use a brush and a non-flexible writing tool to emulate the look of calligraphy. This will come in handy if you need to write on a bigger x-height or on nontraditional calligrapy surfaces.

What Is Flourishing?

A flourish is an elongated pen stroke or linear decorative element that **enhances** a letter's basic form. It's important to highlight the word *enhance* because it stresses that a flourish should never compromise the letterform but only add to its beauty.

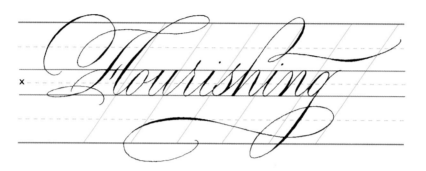

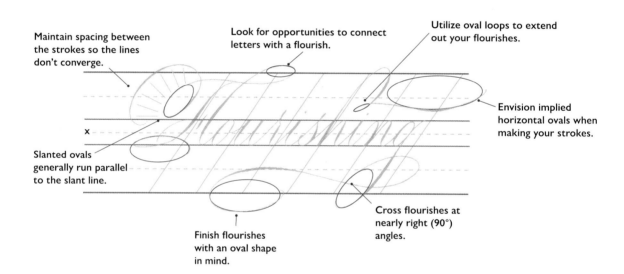

Maintain spacing between the strokes so the lines don't converge.

Look for opportunities to connect letters with a flourish.

Utilize oval loops to extend out your flourishes.

Envision implied horizontal ovals when making your strokes.

Slanted ovals generally run parallel to the slant line.

Finish flourishes with an oval shape in mind.

Cross flourishes at nearly right (90°) angles.

Though flourishing leaves room for creativity and exploration, it should be done within the following basic guidelines:

- **Maintain oval shapes throughout.** The underlying shape in all our flourishes is the oval shape.
- **Intersect strokes at nearly right (90°) angles.**
- **Intersect shade and hairline or hairline and hairline, but never shade and shade.**
- **Maintain visual interest and balance.** Study the negative or white space as much as where you put your pen to paper. Try to avoid lines from converging or diverging as that will draw your eyes to those areas.
- **Strive for graceful curves.** Practice flourishes with a pencil to build up muscle memory. It will help you focus on the flourish shapes.

Flourishing Lowercase Letters

There are five areas to consider when flourishing lowercase letters.

1. **Letters with ascending stem loops.** Letters such as *b*, *d*, *f*, *h*, *k*, and *l* are great places to add flourishes. We can open up the stem loops to extend out the stroke and add additional loops, spirals, or implied ovals.

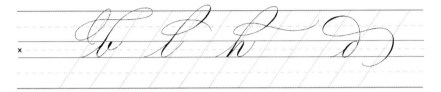

2. **Letters with descending stem loops.** Letters such as *f*, *g*, *j*, *p*, *q*, *y*, and *z* are also great places to add flourishes below the baseline. Feel free to go beyond the second descender line to really elongate the stroke.

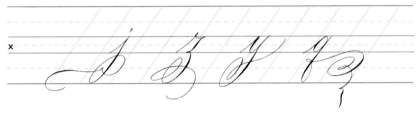

3. **End flourishes.** When you end with a letter that doesn't have any ascenders or descenders, you can still add an end flourish that goes either above the waistline or below the baseline.

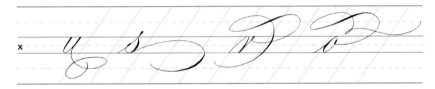

4. **Entry flourishes.** When you want to keep everything in all lowercase letters, it's nice to elongate the entrance stroke for a simple but impactful flourish.

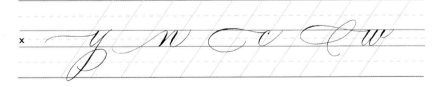

5. **Crossbar of "t."** Lastly, flourishing the crossbar can really soften up the letter *t*. I also like to look for opportunities to connect letters together with a *t* crossbar.

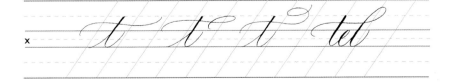

Flourishing Uppercase Letters

The possibilities are endless when flourishing uppercase letters. Keeping ovals in mind, extend out the strokes from the basic letterforms. I've included an exemplar for both Copperplate and Spencerian for you to study and practice with.

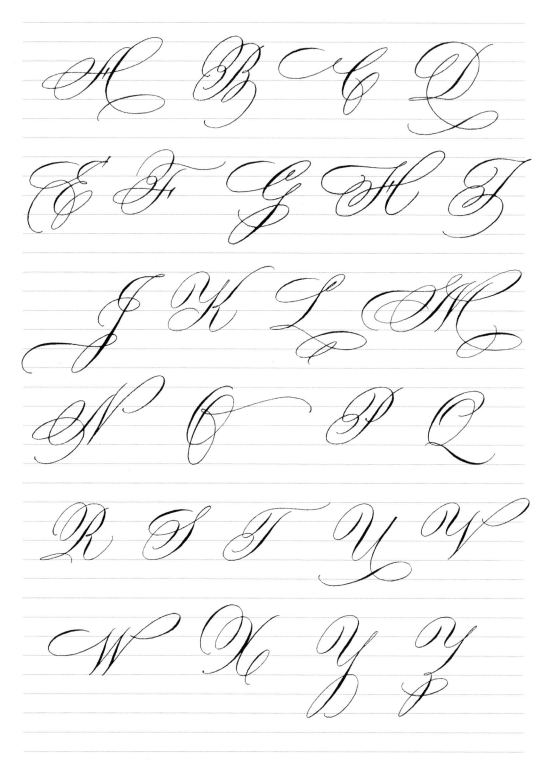

Copperplate uppercase flourish examples.

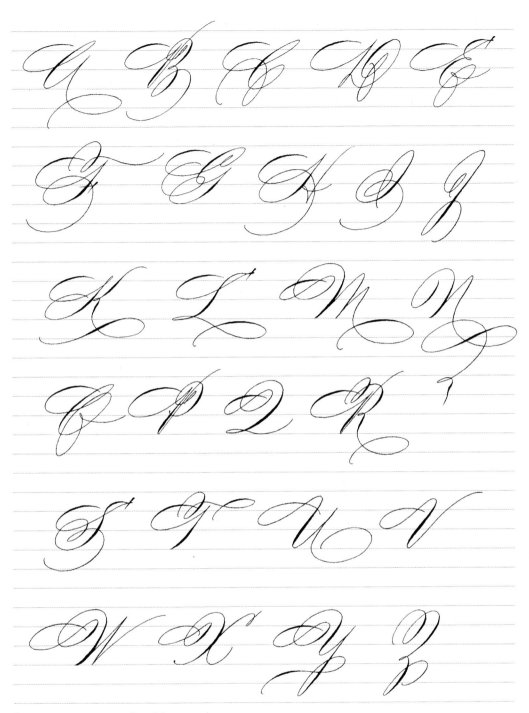

Spencerian uppercase flourish examples.

Brush Lettering

When I want to soften the lines or need to write in a larger x-height, I like to write with brush pens or paintbrushes. Brush pens have a flexible tip with which you can create thin to thick strokes by applying various levels of pressure. As mentioned in the tools section (see page 8), not all brush pens are the same. They will vary in size and flexibility of the tip. *Note*: When you are writing with a larger pen tip, you want to write in a bigger x-height. That way, you'll be able to see a difference between the thins and thicks. Take the time to test and play around with the brushes to get comfortable with them!

Kelly Creates Small Brush Pen (*top*), Ecoline Brush Pen (*middle*), and Prima Marketing Water Brush Pen (*bottom*).

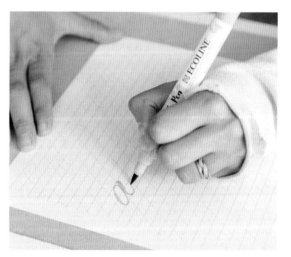

When writing with a brush, hold it at an angle. Start at about a 45-degree angle and adjust accordingly, depending on your hand. This will allow you to apply pressure to the tip without damaging it.

For the hairline strokes, you'll write with the tip of the brush without any pressure. Then, when you want to add shades to your downstrokes, you'll apply pressure to the brush tip as you write.

Now that you know the Copperplate and Spencerian letterforms, you don't have to be confined to the pointed pen. You can practice the letters using flexible brush pens because they are convenient, fun, and colorful. I like to bring brush pens when I'm traveling or on the go because they are so easy to use and don't require clean-up.

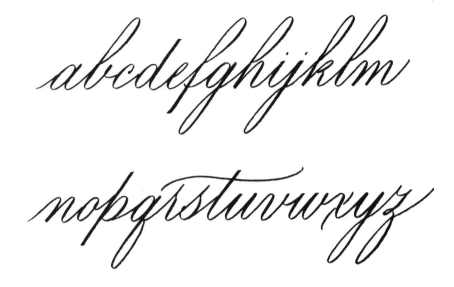

Copperplate script using Pentel Sign Pen Brush.

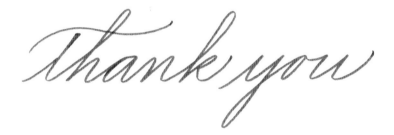

Spencerian script using Pentel Sign Pen Brush.

Faux Calligraphy

Faux calligraphy, or "fake" calligraphy, is a method of writing that imitates the look of calligraphy with any non-flexible tool, such as a fineliner pen, chalk, paint pen, pencil, or ballpoint pen. Knowing how to do faux calligraphy will come in handy when you are working on a non-traditional surface such as wood, glass, fabric, or a chalkboard. It also helps when you have to write in a larger scale that isn't favorable to pointed nibs or brush pens. We use faux calligraphy for some of our projects in this book to draw in additional lines to achieve the shades of your letters.

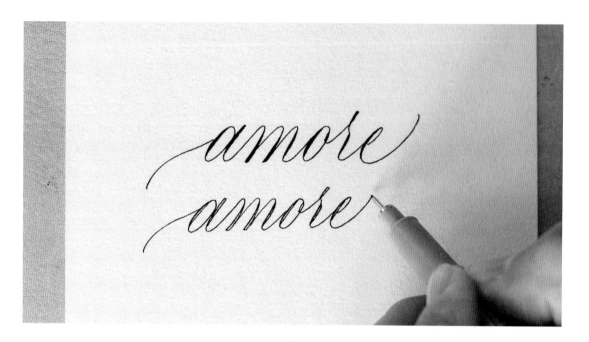

Let's take a look at the letter *a*.

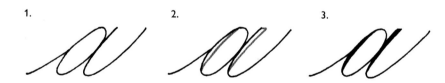

1. First, write out your letter with your writing tool. Whether you are writing in Copperplate or Spencerian, pay attention to the letterform and proportion. This should be written in a single, monoline script.

2. Next, identify where the downstrokes are and draw in additional lines to add weight to your letter. I like to add the additional lines to the right of the initial stroke. Make sure to keep a nice transition from thin to thick to thin. That will help maintain elegance.

3. Fill in the space to achieve the thick shades. When you are done, your finished letter will look like it was written with a brush or pointed pen!

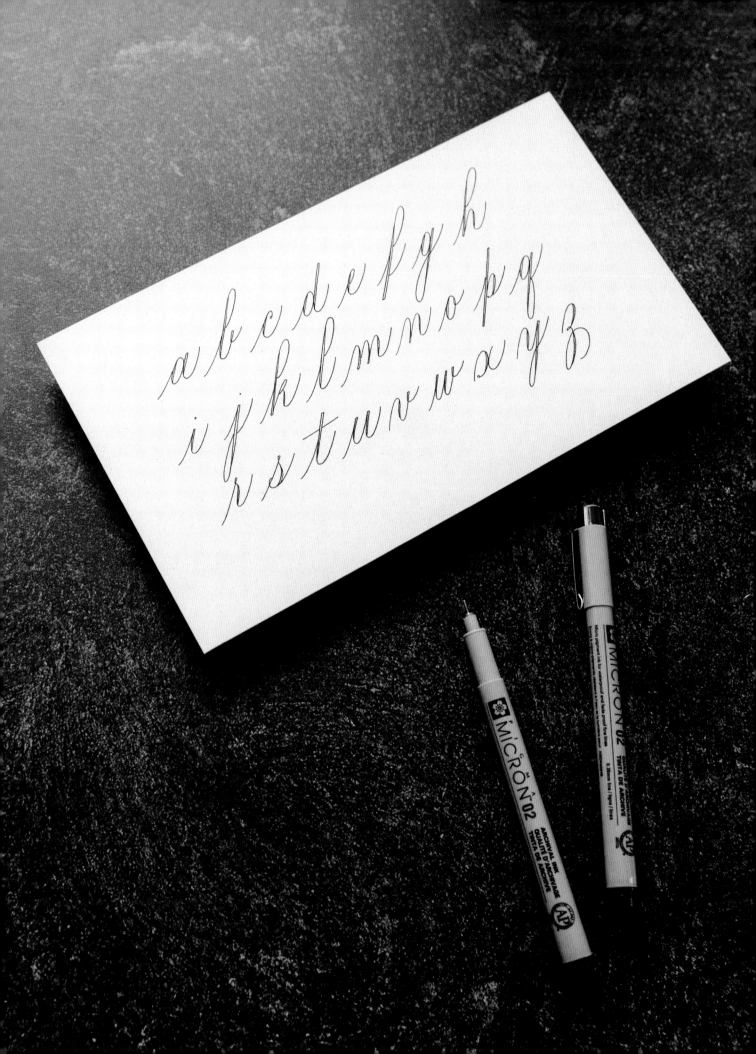

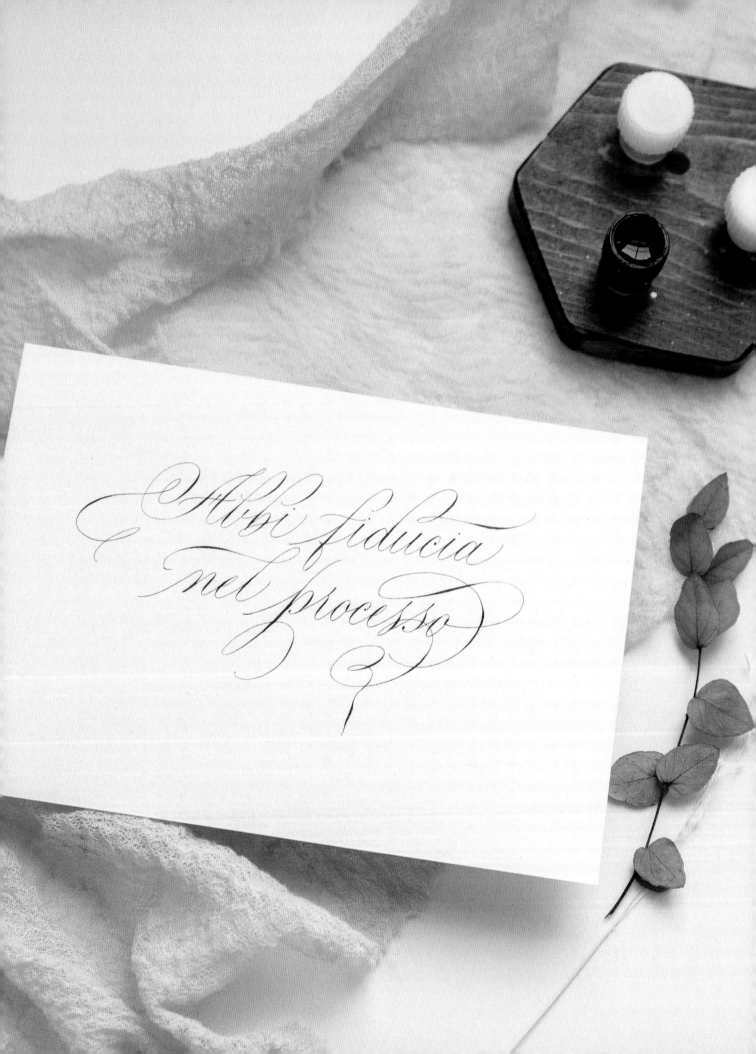

5

Creative Projects

Now that we have learned how to write our letters, let's start creating! It's a great way to practice and make something tangible for yourself or others. I remember early on, I offered to write custom quotes for my friends, and it sparked so much joy during my practice times. Whether it is for celebratory events, for your home, or for personal use, there are so many fun ways to incorporate calligraphy into your daily life.

In this chapter, we will group projects into three main categories: nib, brush, and pen. I hope browsing through these pages will inspire you for your next DIY project. Let's get started!

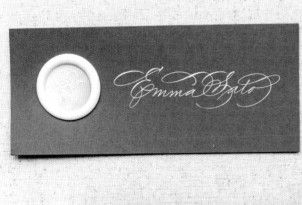
Emma Sato

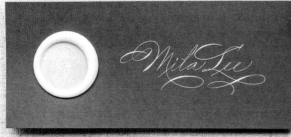
Mila Lee

Angela Wang

Zhang Wei

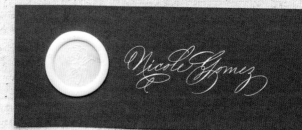
Nicole Gomez

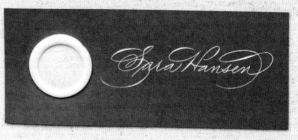
Sara Hansen

Wax Seal Place Cards

Creating personalized place cards is a beautiful way to adorn your space for an intimate gathering or event. You can keep it simple with just the name or add a wax seal on the side. The wax seal adds the perfect timeless element to the place cards. Wax seals were traditionally used to seal envelopes or confidential documents; however, they can also be used for decorative purposes. To make sure the wax seal does not warp the paper, I recommend using at least an 80 lb (216 gsm) cover card stock paper. These place cards are sure to impress your friends, family, and other guests. I love seeing the look on people's faces when they see their names written in calligraphy!

Supplies

- Paper trimmer or ruler and scissors
- Brown card stock paper
- White wax sticks
- Regular size glue gun
- Waterproof permanent pen (0.3 mm Micron pen)
- Wax stamp
- Guide sheet
- Laser level
- *Optional:* Small bowl of ice water and paper towel
- White ink (Dr. Ph. Martin's Bleedproof White)
- Penholder
- Nib

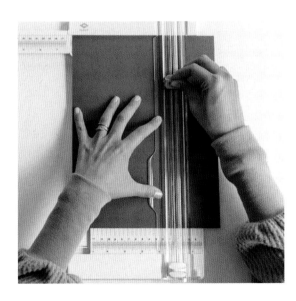

1. With the paper trimmer, cut your card stock paper to 6 x 2½ inches (15 x 6 cm). If you don't have a paper trimmer, you can use a ruler and scissors. Count the number of guests and make cards for an additional 15 to 20 percent in case you need extras.

2. Insert the wax stick into your glue gun. If you can control the temperature, keep it on low heat so it doesn't overheat. As you wait for the glue gun to warm up, mark your wax stamp with a waterproof permanent pen to make sure your design will come out centered.

(continued)

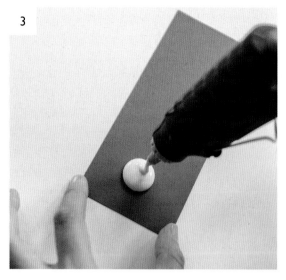

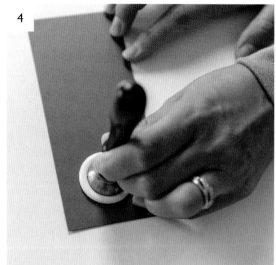

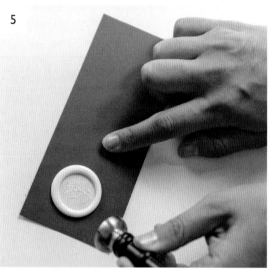

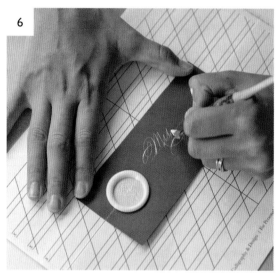

3. Squeeze out about 1 inch (2.5 cm) of wax onto the left side of your paper. On my glue gun, that's about one pump, but it may vary depending on the glue gun you are using. After you pump, release and swirl to keep your wax in place.

4. Looking at where you marked the center, slowly press your wax stamp onto the hot wax. You may want to practice a couple to get the hang of it before you work on the final paper.

5. After about fifteen to twenty seconds, lift slowly and your stamp should release cleanly. If you find that the wax seal is still stuck on your stamp, wait for it to cool and try again.

6. Place your paper on top of a guide sheet and use a laser level to mark your baseline. Dip your nib into the white ink and write the name next to the wax seal. Center according to whether you are writing just the first name or including the last name.

Tip

I like to place my wax stamp in a small bowl of ice water to cool it down between stamps. Make sure to wipe off excess water with a paper towel before using it.

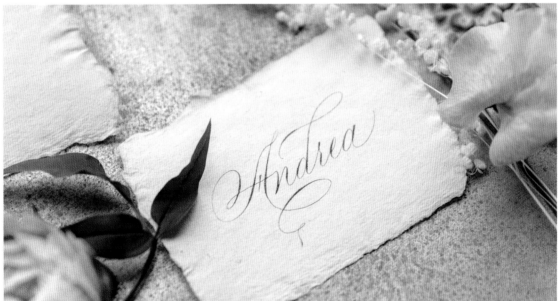

Variation: *Place Card on Handmade Paper.* There is nothing like writing on handmade paper with soft and imperfect deckled edges. You can recreate this look with watercolor paper by hand-tearing it using a deckled ruler, but I personally love the look and feel of handmade paper. Depending on the maker, some handmade paper will be smoother or more absorbent than others. When writing on a slightly textured paper, I like to use a nib with a sturdier tip such as Gillott 404 or Nikko G. Nibs with a sharper tip tend to pick up fibers more easily. If the paper is causing your ink to bleed, try spraying a matte fixative on the paper before you write. You can find a list of my favorite handmade paper suppliers in the Resources section. With all the beautiful colors and papermakers out there, the number of paper and ink combinations are endless!

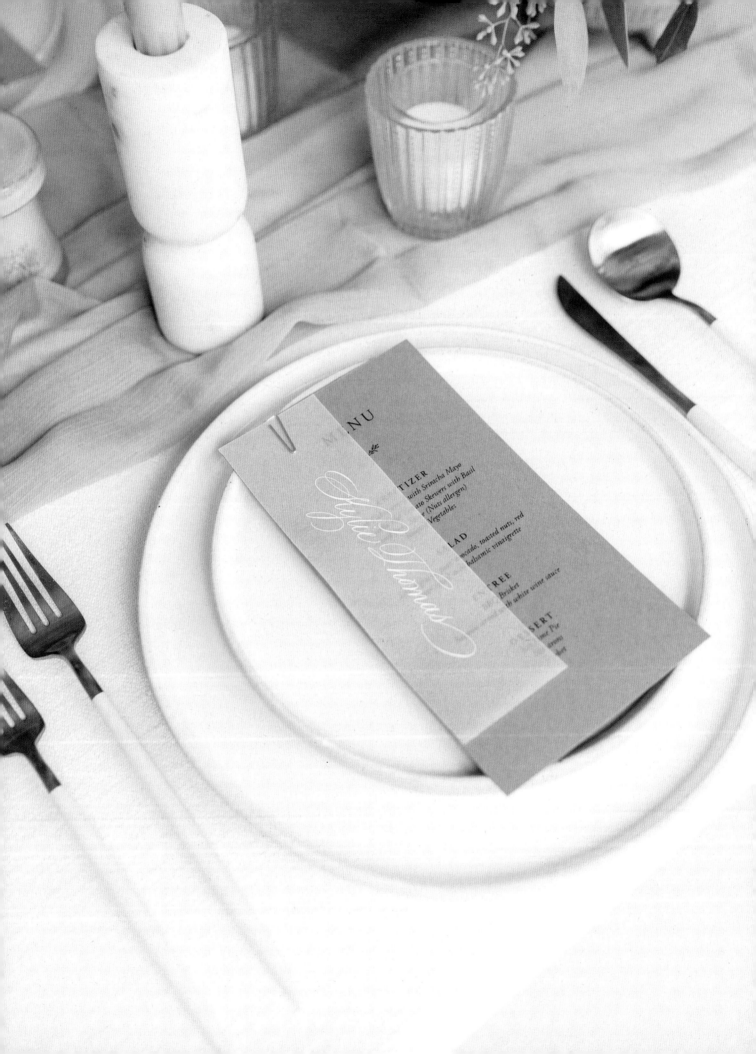

Personalized Menu

To bring your dinner party or celebratory event up a notch, print out menus in advance and personalize them with calligraphy so that your guests can take them home as a memento. I love knowing the menu in advance as it raises excitement for the dinner to unfold. For this project, because we are writing with white ink on vellum paper, it's important to print out the menu on a dark colored card stock paper. This will help bring out the contrast and improve readability of your script. Feel free to switch out the colors of the paper or ink to better match the theme of your event.

Supplies

- Paper trimmer
- Vellum paper
- Guide sheet
- Laser level
- Paper clip

- White ink (Amsterdam Acrylic Ink, Titanium White)
- Penholder
- Nib

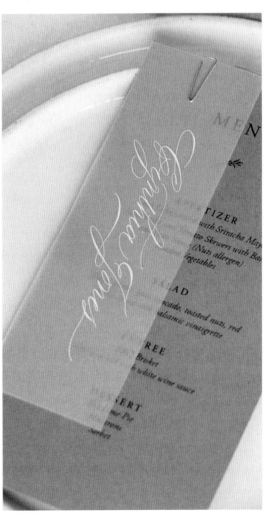

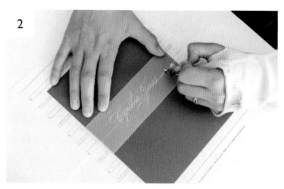

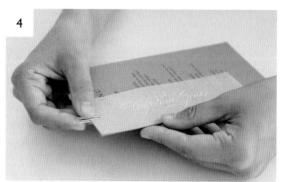

1. With your paper trimmer, cut the vellum paper to 2 x 6½ inches (5 cm x 16.5 cm). You can trim one side after writing the name to adjust to the name's length. Count the number of guests and make enough for an additional 15 to 20 percent in case you need extras. Place the vellum paper on top of your guide sheet and use the laser level to mark your baseline.

2. Directly load the ink on the front and back of the nib using the dropper from the ink bottle. Scrape the nib along the side of the jar to get rid of any excess ink. Leave about a 1½ inch (4 cm) margin on the left side of the vellum and begin writing out the name.

3. After you finish writing, trim the other side of the paper if needed.

4. Place the personalized vellum paper on top of your menu card and use a paper clip to secure it in place.

5. Lastly, place it on top of each place setting and be ready to impress your guests!

Tip

To help see the vellum paper as you write, place a piece of dark colored paper between the vellum and the guide sheet.

Cheeseboard Food Labels

Need an idea for a perfect appetizer? Charcuterie boards are versatile, colorful, and fun to make! Begin by choosing a board size and slowly build it up by adding a variety of cheese, meat, crackers, fruit, nuts, and condiments. Guests may have a hard time differentiating between the cheeses (I know I do), so for this project, we will create our own cheeseboard labels.

A note about scoring paper: Like mine, some paper trimmers come with a scoring option. If you can't find a scoring tool, you can use a ruler and a bone folder to hand-score your paper. Scoring the paper in advance will allow you to fold the paper cleanly.

Supplies

- Paper trimmer
- Scorer
- Card stock paper
- Guide sheet
- Laser level
- Bamboo pick

- Double-sided tape
- Scissors
- Walnut ink
- Penholder
- Nib

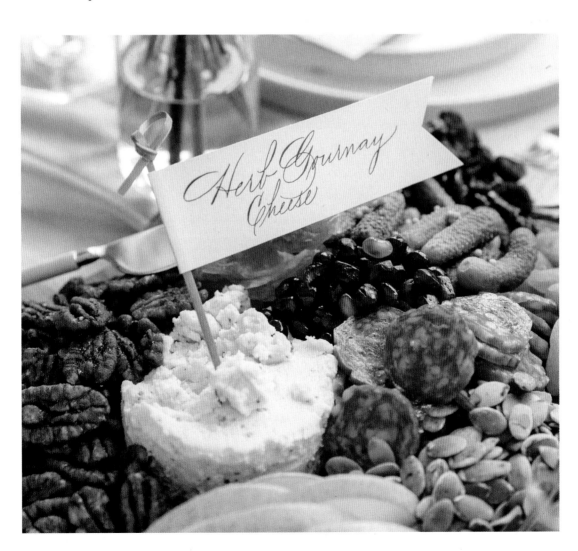

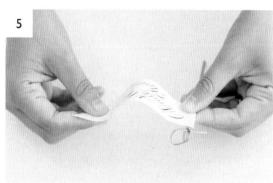

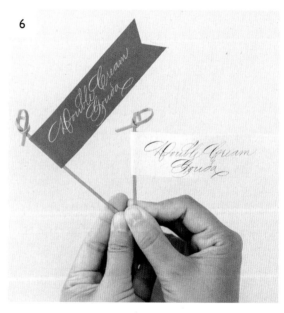

1. With a paper trimmer, cut the card stock paper to 5½ x 1¼ inches (14 cm x 3 cm) and score the paper at 1 inch (2.5 cm) from the end. Count the number of labels you will need and make extras just in case. Place the paper on top of your guide sheet and use a laser level to mark your baseline. Dip your nib into walnut ink and write your labels.

2. Flip the paper to the back and place a piece of double-sided tape on the 1 inch (2.5 cm) side that you scored before.

3. Align the bamboo pick with the scored line. Fold and press down on both sides of the paper with your fingers to secure.

4. Cut a triangle shape on the other side with your scissors to make a banner.

5. Using your fingers, you can gently bend your paper to create a wavy look.

6. **Variation.** You can also write on colored paper using white ink.

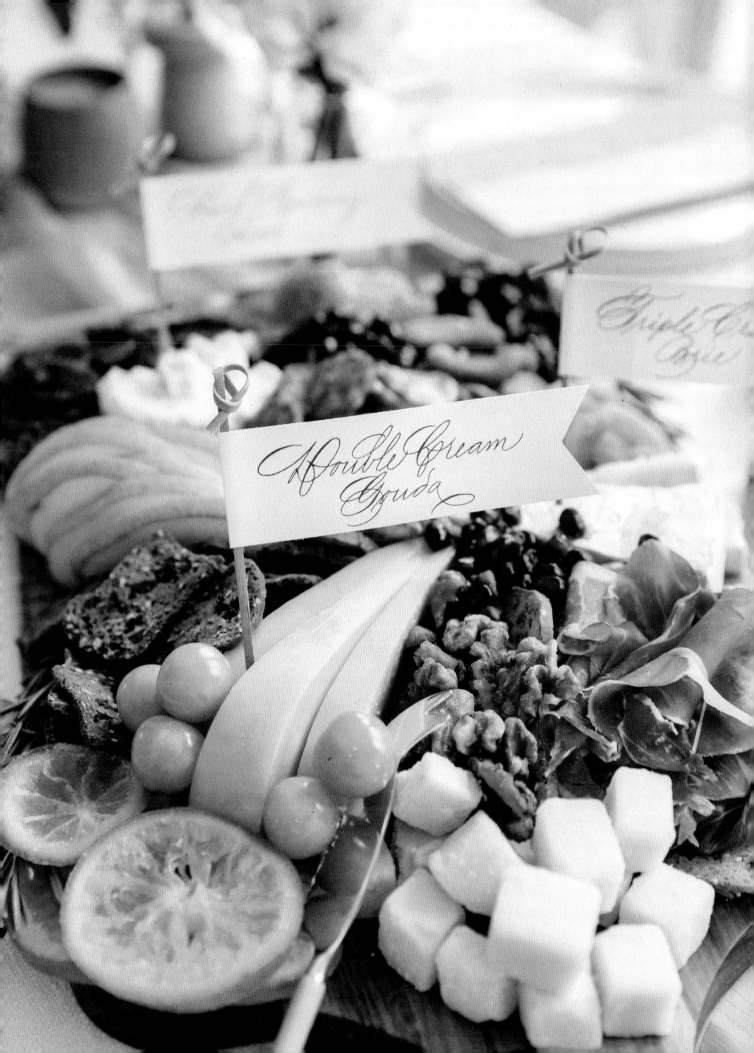

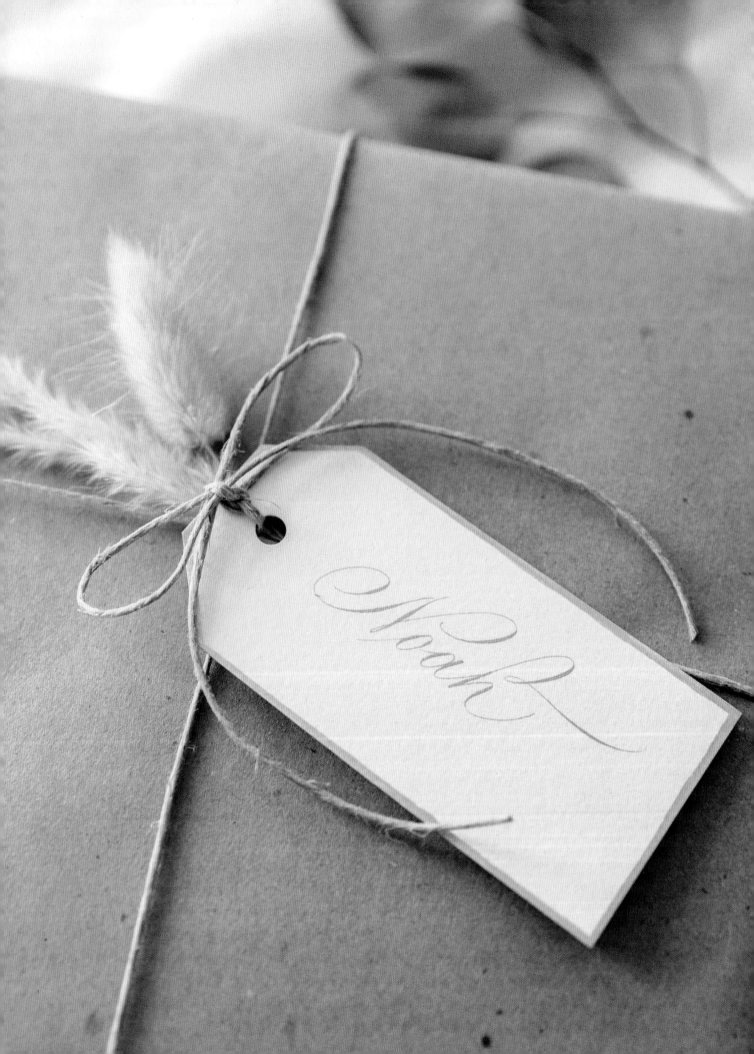

Gold-Trimmed Gift Tags

I remember that one of the first projects I did after learning calligraphy was making my own gift tags. Not only is it a fun way to get in some practice, but it brings so much joy in gift giving. I love taking the time to write out the names of my friends and family for their birthdays or special occasions. For this project, I'll be sharing three ways to add gold elements to your gift tags using my favorite metallic watercolor—Finetec.

Supplies

- Paper trimmer
- Watercolor paper (Canson XL cold-pressed watercolor paper)
- Hole puncher
- Guide sheet
- Laser level
- Finetec, Arabic Gold
- Small flat brush
- Water in dropper bottle
- Twine
- Penholder
- Nib

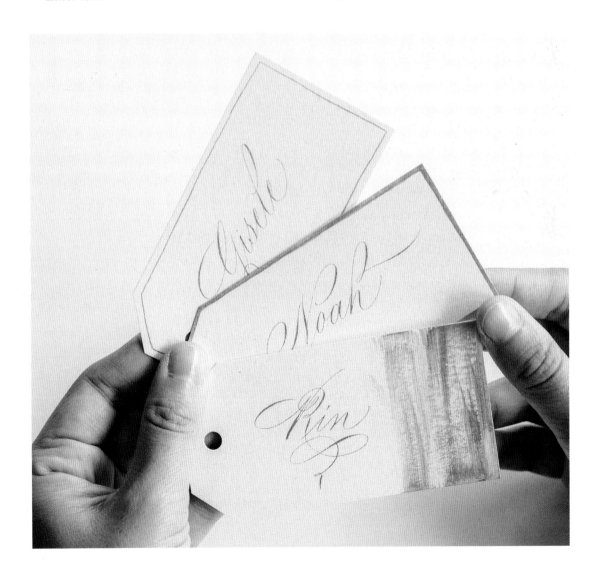

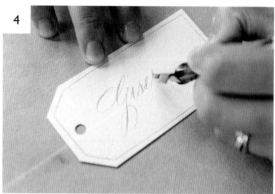

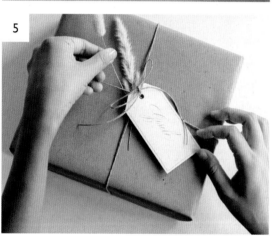

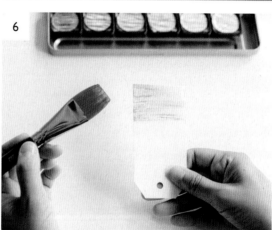

1. With your paper trimmer, cut paper to 2 x 4 inches (5 cm x 10 cm). Count the number of tags you will need and make extras just in case. First, hole punch at the center along one side of the tag. Then, on the same side, cut two triangle shapes off the edges. I like to eyeball where the bottom of the hole is and cut the triangle along the same line.

2. Add a couple drops of water onto the gold Finetec pan and gently mix together with the brush until you get a milk-like consistency. Load the Finetec onto the nib by brushing it on the front and back.

3. Without any pressure, draw a thin gold outline around your gift tag.

4. Using your laser level, mark your baseline along the bottom of the hole. Write the name of the gift recipient.

5. Add the tag to your gift using the twine. Feel free to incorporate dried florals or greenery for that final touch!

6. **Variations.** Instead of a thin gold outline, you can also paint along the edges with a small flat brush or brush one side of the tag using a 1 inch (2.5 cm) wash brush.

"Thank You" Cards

"There is always, always, *always* something to be thankful for." This is one of my favorite sayings, and something I try to practice and strive toward on a regular basis. Whether you verbalize it or write it in a card, saying thank you to the people in your life is a priceless and thoughtful gesture. In this project, I'll be showing you two different ways you can create thank you cards: one in Spencerian and another in Copperplate.

Supplies

- Copperplate/Engrosser's graph pad
- Paper trimmer
- Brown card stock paper
- White watercolor paper
- Finetec, Arabic Gold
- Penholder
- Nib
- Ruler

- White ink (Dr. Ph. Martin's Bleedproof White)
- Pencil and eraser
- Brown gouache and dinky dip
- Yellow watercolor
- 1 inch (2.5 cm) wash brush
- Small brush
- Light pad

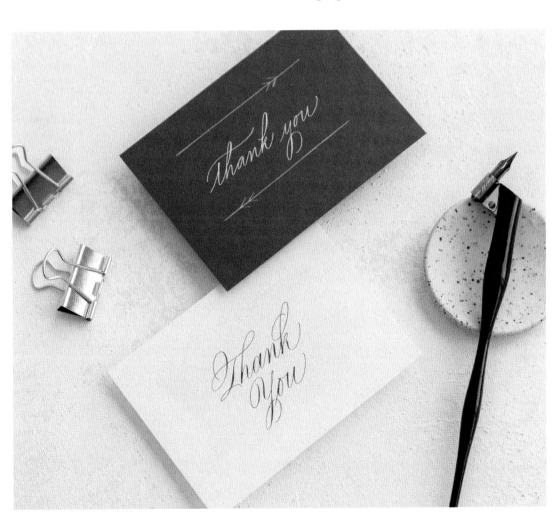

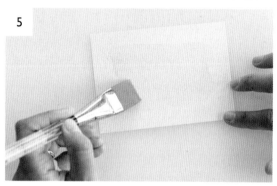

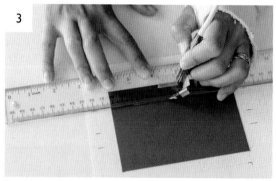

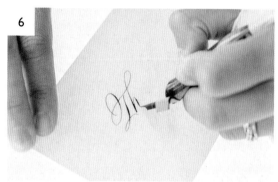

1. Mark the dimensions of the card and sketch out designs on the Copperplate/Engrosser's graph pad. I will be writing "Thank you" in Spencerian with lines for one and "Thank You" in Copperplate for another. The dimensions will be 3½ x 5 inches (9 cm x 13 cm).

2. Because we will be writing on colored paper, it also helps to mark the baseline along the sides as well as on the top where the letters and lines should begin. That way, we can use those markers later with the laser level.

3. Using the paper trimmer, cut the brown card stock paper to 3½ x 5 inches (9 cm x 13 cm). Apply Finetec gold to the nib front and back with a small brush. Place the brown card stock paper on top of your sketch. Then, with a ruler, line it up with the markers and draw the lines with your nib.

4. Add arrows to the lines, going in the opposite direction. Next, dip your nib into the white ink and write "Thank you."

5. For the second design, we will be writing on a white watercolor paper. First, squeeze some gouache into a dinky dip. Add a couple drops of water and mix until it reaches a milk-like consistency. Cut the paper to size and paint a light wash using a 1 inch (2.5 cm) wash brush.

6. After the watercolor dries, place the paper on top of the sketch and place both on top of the light pad. Write "Thank You" with your nib and brown ink.

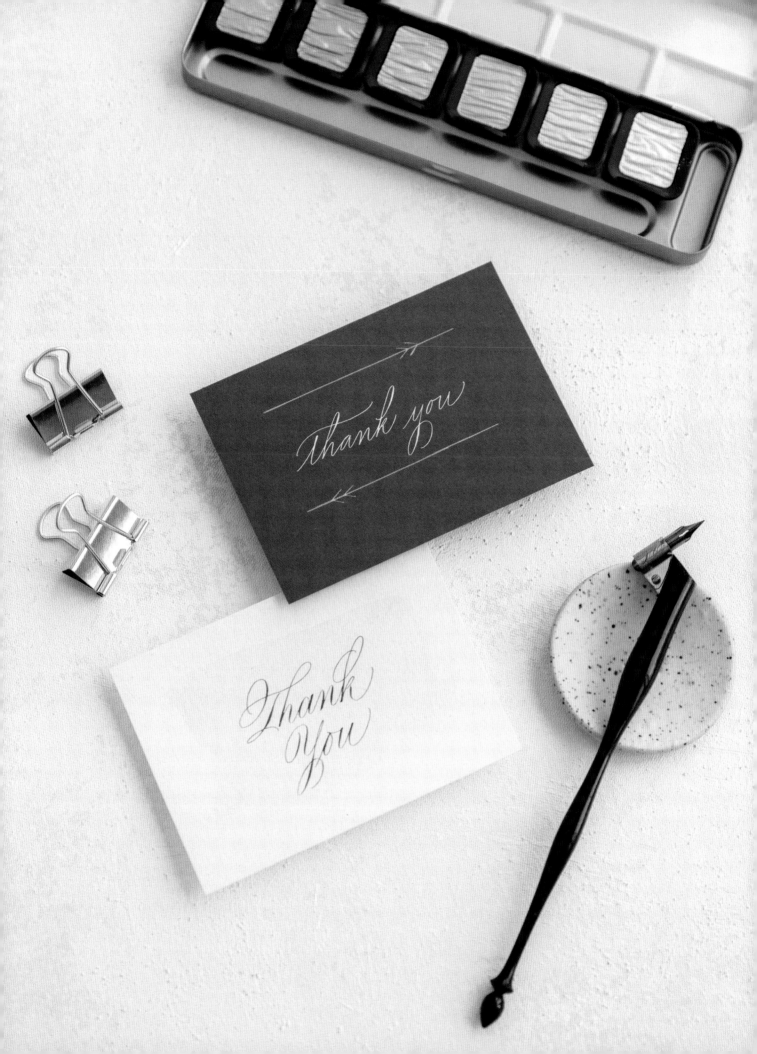

Birth Details Photo Mat

If you are expecting a baby or know someone who is, this project will be a memorable one-of-a-kind keepsake for the home! We will create a custom photo mat to write down all the special details of the baby's birth. I love mixing both Copperplate and Spencerian script, so for this project, we will be writing the name in Copperplate and the birth details in Spencerian.

Supplies

- Paper trimmer
- Copperplate/Engrosser's graph pad
- Watercolor paper (Canson XL watercolor paper)
- Pencil and eraser
- X-Acto knife
- Ruler

- Cutting mat
- Light pad
- Penholder
- Nib
- Black ink (Moon Palace Sumi Ink)
- Washi tape
- 8 x 10 inch (20 cm x 25.5 cm) frame

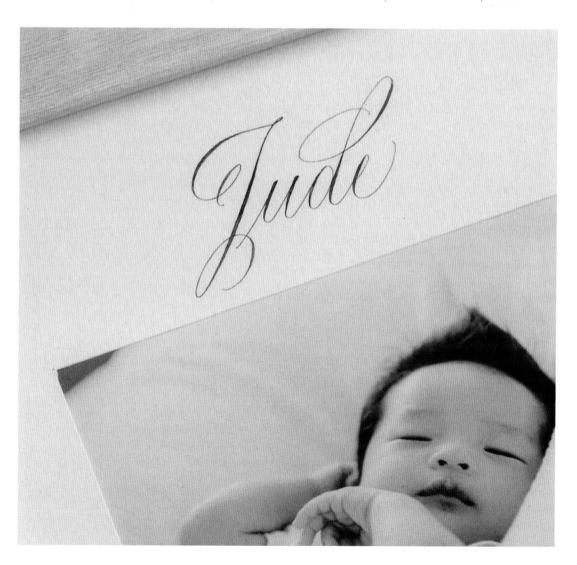

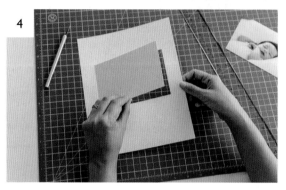

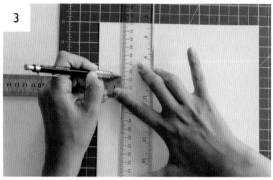

1. On the Copperplate/Engrosser's graph pad, mark the size of the overall piece (8 x 10 inches [20 cm x 25.5 cm]) as well as the size of the photo you will be using (4 x 6 inches [10 cm x 15 cm]). Place the photo a bit higher than the center, as we will need more space below the photo to write out the birth details.

2. Sketch out the first name above the photo in Copperplate script. Then, sketch out the birth details below the photo in Spencerian script. Cut the watercolor paper to 8 x 10 inches (20 cm x 25.5 cm) using the paper trimmer.

3. Place the paper on the cutting mat. Then, use rulers to mark where you will place the photo. Instead of marking it exactly at 4 x 6 inches (10 cm x 15 cm), you want to mark ⅛ inches (3 mm) inward from the size of the photo so that the photo will be secured behind the mat.

4. Cut out the area where you will be placing the photo with an X-Acto knife. Gently remove it with your fingers.

5. Using the light pad, place the final paper on top of your sketch and write it out with a nib and black ink.

6. Once the ink dries, flip it over to the back and secure the photo with washi tape. Place it in the frame and now you have a way to remember this memorable birth event!

Frosted Winter Wreath Design

Growing up on the east coast, I remember looking forward to winter to catch the first snow. I love all the festive decorations and traditions that happen during that time—snowball fights, school closures, and colorful lights that lit up the whole neighborhood at night. In this project, I will show you how to create your own frosted winter wreath. You can use this design for a card or frame it to hang as a decoration in your home.

Supplies

- Paper trimmer
- Black card stock paper (at least 80 lb [216 gsm])
- Penholder
- Nib
- White ink (Dr. Ph. Martin's Bleedproof White)

- White mechanical pencil (Fons & Porter mechanical pencil)
- White colored pencil
- Circle stencil
- Finetec, Brilliant Rust or any metallic red color
- Sakura Stardust gelly roll pen

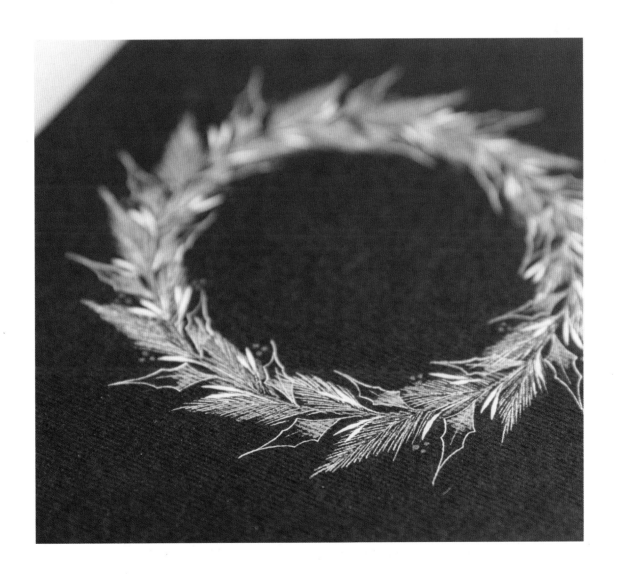

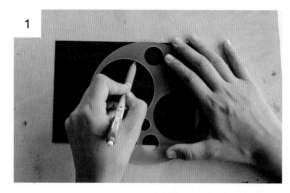

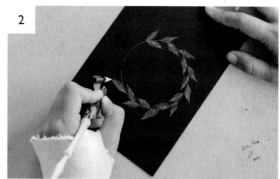

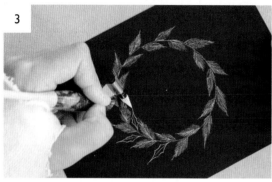

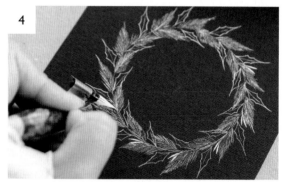

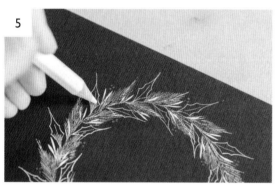

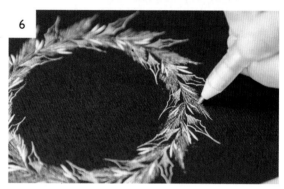

1. Using the paper trimmer, cut card stock to 4 x 6 inches (10 cm x 15 cm). Place the circle stencil at the center of your paper and outline the shape with the white mechanical pencil.

2. Dip the nib into the white ink and begin by drawing pine leaves around the circle.

3. Next, add holly leaves in the open spaces between the pine leaves. If there's extra space left, fill it in with more pine leaves.

4. Add wheat strokes in pairs onto your wreath. Wheat strokes are created by adding and releasing pressure to create a tear drop shape.

5. Load red Finetec onto the front and back of your nib. Add berries around the wreath by creating a cluster of three small dots. Next, with the white colored pencil, color in the bottom part of the holly leaves to add depth. You can also use the colored pencil to color in the pine leaves to make the wreath look full.

6. To add some shimmer, go over some of the pine leaves with the Stardust gelly roll pen.

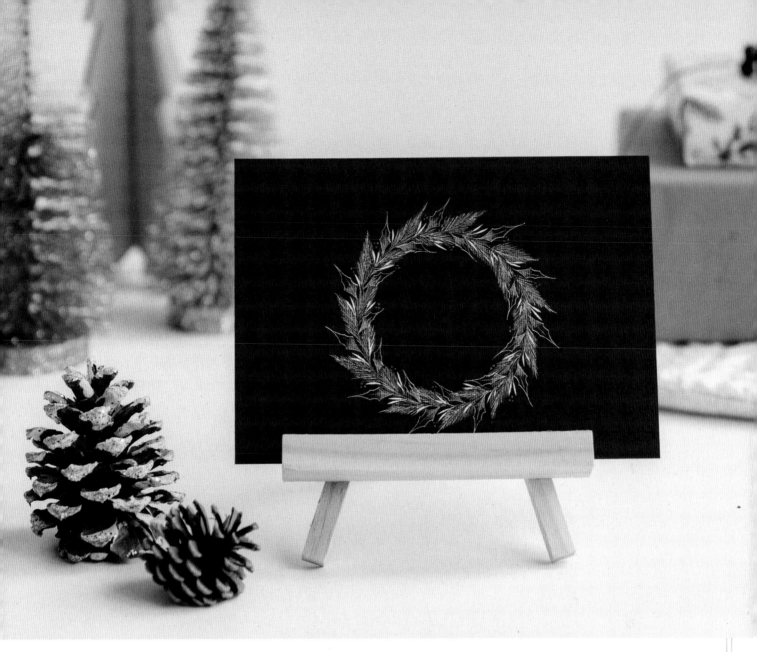

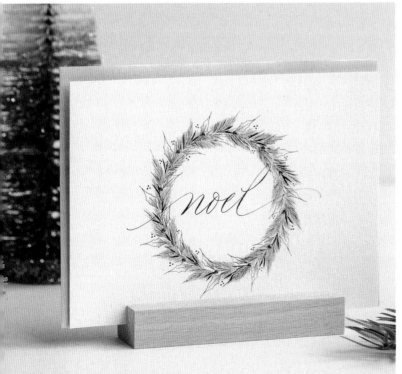

Variation *"Noel" Wreath Design.*

This colorful version features watercolor, colored pencil, and gems. The main color is green with some red accents—the word "Noel" and the berry trios—and finished with green sticker gems that add shine, texture, and dimension. Use a nib loaded with green watercolor to draw pine leaves around the circle in alternating directions, add holly leaves in the open spaces between the pine leaves, and then add pairs of wheat strokes, which are created by adding and releasing pressure to create a teardrop shape. Use green colored pencil to add color and depth to the bottom of each holly leaf.

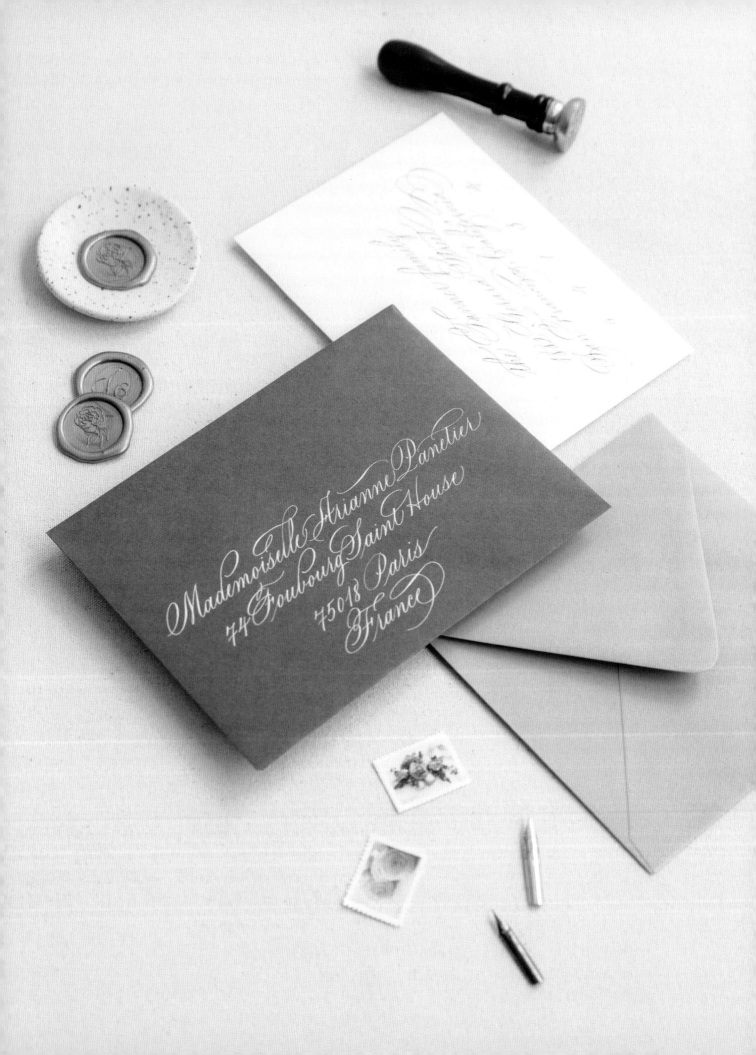

Addressing Envelopes

When was the last time you sent or received a beautiful envelope in the mail? When I first started my journey in calligraphy, I participated in various envelope exchanges and would eagerly check my mail for the handwritten envelopes. I still have a box in my studio filled with snail mail that I have received over the years from my students and calligrafriends. Whenever I look through the box, it brings me so much joy.

In this project, I'll be sharing some tips when it comes to addressing envelopes. Whether you have a wedding or other event to prepare for or want to send someone a card, I hope this will inspire and motivate you to send more handwritten envelopes!

Supplies

- Envelope addressing template
- Laser level (for colored envelopes)
- Blotter/writing pad
- Light pad (for white envelopes)
- Envelopes
- Stamps

- Penholder
- Ink
- Nibs
- Water and paper towel
- *Optional:* Envelope drying rack

SETTING UP

Before we begin, we want to set up and organize our writing space with the needed supplies for an efficient workflow. As a left-handed calligrapher, I usually have a stack of envelopes (plus an extra 10 to 15 percent) and my penholder, ink, and nibs on the left side of my desk. Then, depending on whether I'm working with colored or white envelopes, I'll set up my blotter pad or light pad in front of me with a list of addresses at the top edge of the desk. As I finish writing one envelope, I will lay it out on the right side of the desk to dry. It's important to have ample space on your desk for about eight to ten envelopes to dry at a time. An alternative would be to purchase an envelope drying rack, which will keep your envelopes upright at an angle to save desk space.

I also recommend testing one envelope with the nib and ink. Envelopes come in different textures, thicknesses, and absorbencies, so testing will help you avoid bleeding or ink flow issues. For example, when I work with metallic ink such as Finetec, I find that the Gillott 404 nib works the best versus Nikko G or Leonardt Principal EF. If your envelope has a bit of texture, you may want to use a nib with a sturdier tip so that it does not catch on the paper fibers. Taking the time to properly test will save you a headache and save your envelopes from going to the trash.

LAYOUT

You also want to figure out how to lay out the address on the envelope. Common layouts that I've seen are left justified and centered. You can write the address in three lines or move the postal code to the fourth line. To help with visualizing the layout, I like to print out the addresses on a sheet of paper. Here is an example:

Left justified:

Mr. and Mrs. Bruno Garcia
4 Yawkey Way
Boston, Massachusetts
02215

Centered:

Mr. and Mrs. Bruno Garcia
4 Yawkey Way
Boston, Massachusetts
02215

Left justified is pretty self-explanatory, but seeing the addresses printed out like this will help me estimate where to begin writing when I am doing a centered layout.

Envelope Addressing Template. I find that it's easier to use templates rather than penciling in guidelines for your envelopes. I've created my own template (you can find it in the Resources section) that you can download and use for your envelopes. I created a 5 mm template for bigger envelopes and 4 mm template for A7 or smaller envelopes. The baseline is spaced just enough that you can incorporate flourishes without the envelope looking cramped. There is also a vertical line for when you need to center envelopes.

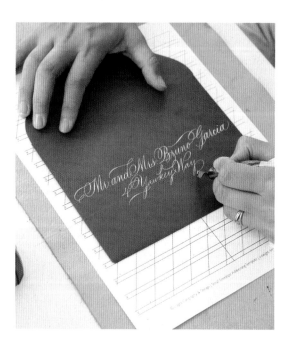
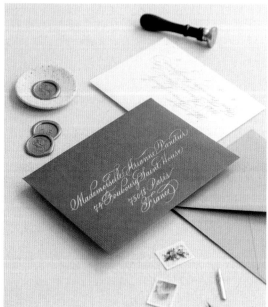

1. When working with white envelopes, use a light pad so that you can see the guide sheet underneath the envelope. If you are working with colored envelopes, place the envelopes on top of the guide sheet and use the laser level to mark the baseline. I like to leave about 1 inch (2.5 cm) as a margin on the bottom of the envelope, so keep that in mind before writing on the envelope.

2. Now, look at the address on your reference sheet and see how much space you will need to write the first line. The space needed will also depend on the length of the names, the size of the envelope, and whether you are addressing the envelope to a single person or a couple. What helps me is to make a vertical line down the center of my reference sheet to see how many words are to the left and right of the center line.

3. After you write the first line, look at the reference sheet again to see where to begin the second line, and so forth.

4. After you finish writing out the address, make sure you have the right postage. It's now ready to be sent out! *Note:* If you are using things like wax seals or bulkier envelopes, it may be best to get the envelopes hand-cancelled so that they don't get damaged by the machines during the sorting process. This option will require a higher postage, so make sure to check with your post office to see if that is available in your area.

Tip

To help center the postal code, write the middle number first, then the first and the last number. Finally, fill in the rest of the numbers. This trick has saved me so many times.

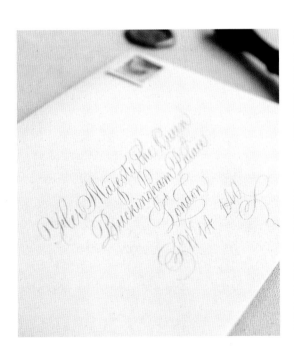

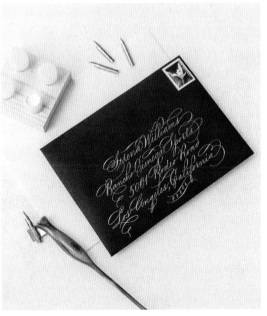

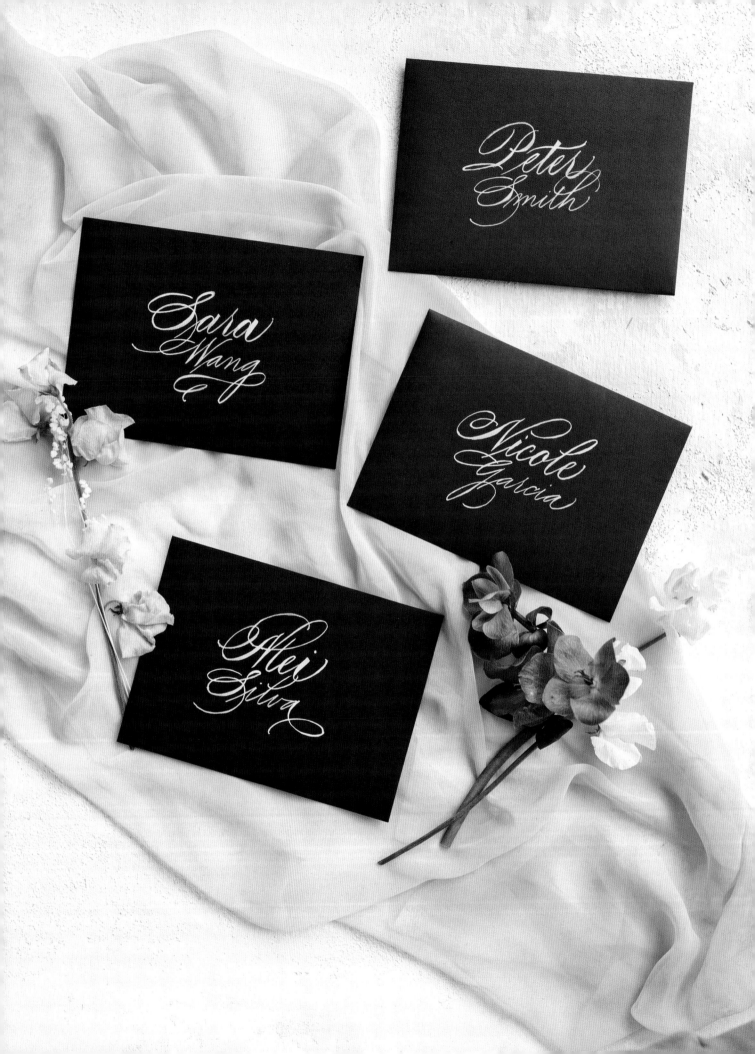

Personalized Outer Envelope

Whether for birthdays, holidays, anniversaries, or just because, I still love giving and receiving cards. What better way to hand someone a card than with a personalized envelope? In this project, we will be writing the first name in Copperplate and last name in Spencerian. These two scripts complement each other wonderfully and work well when the names are arranged in two separate lines.

I love using a brush for calligraphy when I want to write in bigger letters. It also gives a slightly textured look versus using a pointed nib. Depending on the flexibility of the brush tip, you can play around with the amount of pressure to adjust the thickness of the shades.

Supplies

- Colored envelope
 (A7 size: 5.25 x 7.25 inches
 [133.35 mm x 184.15 mm])
- Water brush (Sakura Koi small
 water brush)

- White ink (Dr. Ph. Martin's
 Bleedproof White)
- Envelope guide sheet template
- Laser level

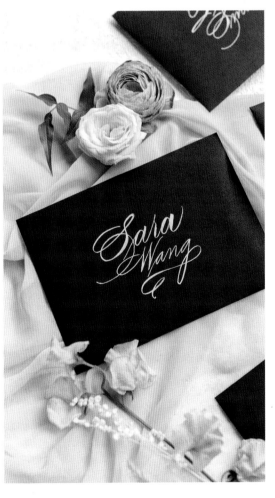

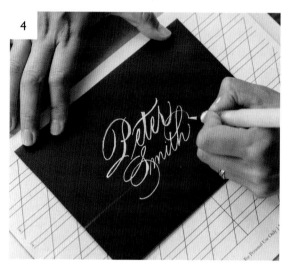

1. Place your colored envelope on top of the envelope template and use the laser level to mark your baseline. Because we are using two lines, I like to keep my first baseline slightly higher than half the height of the envelope. For this envelope, which is 5¼ inches (13.5 cm) high, my baseline is at 2½ inches (6.5 cm) from the top.

2. Dip your brush into the white ink. Scrape off any excess ink at the edge of the ink jar to prevent ink from pooling on the envelope. Begin writing the first name in Copperplate script. You can choose to keep it simple or add some flourishes.

3. As you write across the envelope, don't forget to move the envelope with your non-writing hand. This will help you write in that sweet spot rather than bringing the hand too close or too far from your body.

4. After writing the first name, move the envelope up and write the last name in Spencerian. Don't be afraid to intersect strokes. To help keep the strokes nice and thin, try holding the brush at a higher angle.

Tip

After centering the envelope, I like to use my non-writing fingers to mark my writing area.

"Happy Birthday" Banner Signage

I have so many fond memories of celebrating birthdays with my family. No matter how busy our schedules can be, we always made time to do something special for one another. Now as a mom of three boys, I love passing down the tradition of celebrating life and creating new memories with them! My son Jude turned two while his grandparents were here visiting, and this banner signage turned out to be the perfect photo backdrop. Creating your own banner signage is easy, and banners can be customized to any celebratory event.

Supplies

- Paper trimmer
- Hole puncher
- Card stock paper (Kraft or color of choice)
- Scissors
- Ribbon

- White ink (Dr. Ph. Martin's Bleedproof White)
- Gold pen (Sharpie Fine Point Gold Permanent Marker)
- Brush

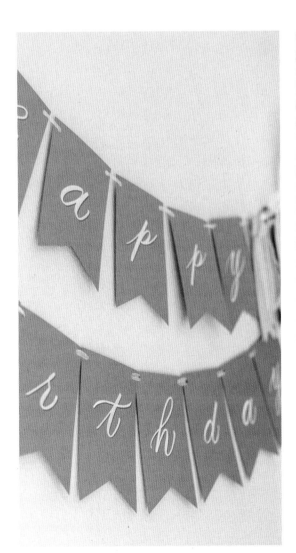

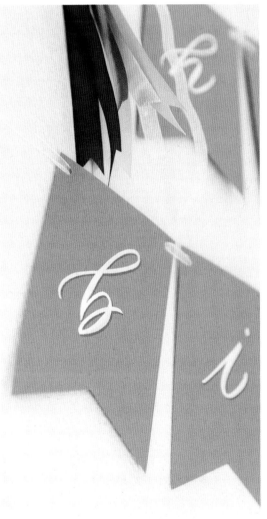

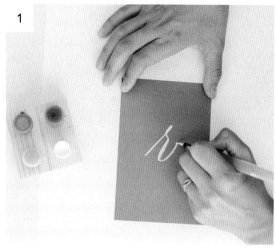

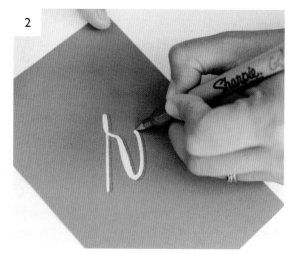

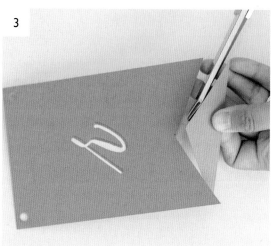

1. With your paper trimmer, cut paper to 4 x 6 inches (10 cm x 15 cm). Dip the brush into the white ink to write your letter. Begin writing your letters at about 2½ inches (6.5 cm) from the bottom and leave 1½ inches (3 cm) from the top to accommodate the ribbon later.

2. Add a drop shadow using a gold pen by outlining to the right of the letter.

3. Hole punch ¼ inches (0.5 cm) from the top on both corners. Mark the center with a pencil at about 1 inch (2.5 cm) from the bottom and cut out a triangle shape.

4. String the ribbon through the letter cards to make a banner.

5. Tie a bow at the end and add other colorful ribbons to match the theme of your event. Hang it on the wall and add balloons. Now you have a great photo backdrop!

Cake Topper

Confession: I have the biggest sweet tooth. Ice cream, boba, macarons, chocolate chip cookies, cakes . . . you name it. No matter how full I am after a meal, I always tell my husband I have a separate compartment in my stomach for a bit of sweetness. For this project, we will be jazzing up our cake with a customized topper. Using simple materials around the home, we will create a two-toned mini banner topper to adorn the cake.

Depending on how many banners you need and the size of your cake, you may need to make two strings of banners on top of each other. From "Cheers" to "Just Married" to numbers, this project will leave you itching to think of other ways to customize your next cake topper!

Supplies

- Paper trimmer
- Cardstock paper (white and colored)
- Bamboo skewers
- Double-sided tape
- Scissors
- Brush pen (Pentel or Kelly Creates)
- Needle
- Ribbon

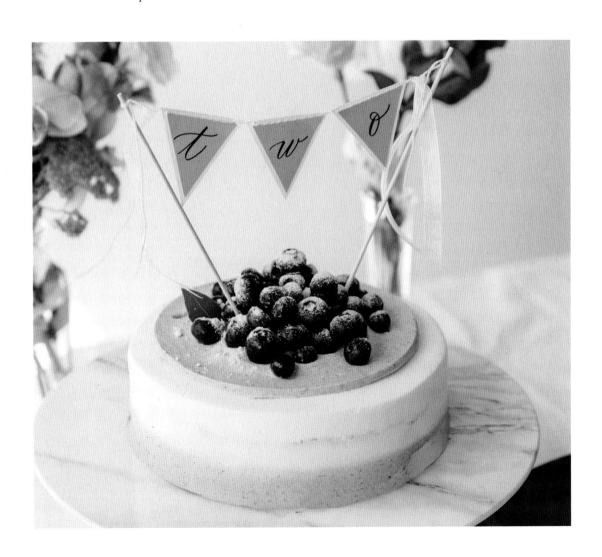

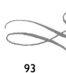

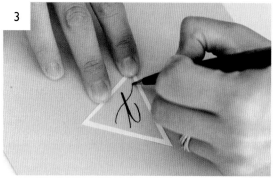

1. Cut the white cardstock paper to 2 x 2 inches (5 cm x 5 cm). Cut the colored cardstock paper slightly smaller to 1⅝ x 1⅝ inches (4 cm x 4 cm). Make sure to have extra paper cut out in case it is needed. Mark the center on one side of the white paper with a pencil and cut it into a triangle. Do the same with the colored paper.

2. Place the colored paper on top of the white paper and secure it with double-sided tape.

3. Using a brush pen, write the letter on each of the triangle papers.

4. Poke a hole into the corners using a needle. *Note:* We are not using a standard hole puncher due to the small size of this paper. Connect the letters together with a string.

5. Wrap the string around the bamboo skewer and tie a knot to secure it.

6. Add another ribbon at the ends to make a bow. Gently insert the topper into your cake!

Gift Wrapping Paper

Kraft paper is quickly becoming my go-to gift wrapping. I buy it in a large roll and am able to use it all year long. I love how classy it looks, and with the right accessories and ribbons, you can keep it simple or dress it up as much as you want. In this project, I'll show you how you can create your own calligraphy wrapping paper using a brush pen. You can also use a nib, but I personally like writing with a brush pen because I don't have to worry about smearing ink or waiting for the ink to dry. With all the colors available for brush pens, it's also fun to try different color combinations with Kraft paper. Have fun with it!

Supplies

- Kraft paper
- Brush pen (Ecoline brush pen)
- Scissors
- Tape
- *Optional:* Ribbon, laser level, ruler, pencil

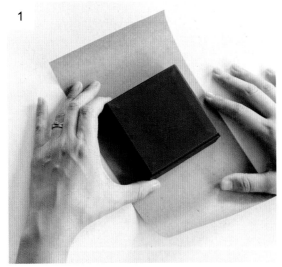

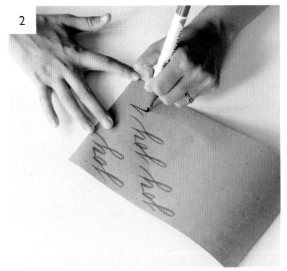

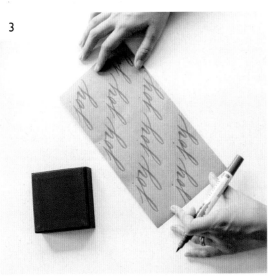

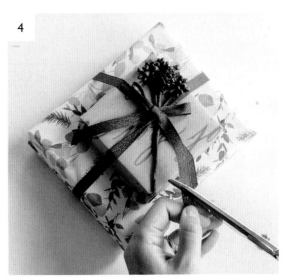

1. Cut your Kraft paper to size using your scissors. The size depends on the size of your box. I like to keep a 1 to 1½ inches (2.5 cm to 3.5 cm) margin on the sides and make sure the top and bottom overlap.

2. Write at approximately 45 degrees using a brush pen. *Note:* If the paper size is small, I eyeball the baseline to keep it straight; however, if you are working on a large paper size, it will help to draw in your baseline using a ruler and pencil. You can also use a laser level to help mark your baseline.

3. Leave ample space between your baselines so that your letters won't look constricted. For this example, my x-height was ½ inch (1.5 cm), and I spaced my baselines 2¼ inches (5.5 cm) apart.

4. Wrap your gift with your newly created wrapping paper! Add finishing touches with a ribbon or twine. You can also add other decorative elements such as trinkets or flowers for a pop of color.

Personalized Kraft Notebooks

Two things have changed since I became a calligrapher. First, my eyes are drawn to letters everywhere I go—billboards, shop logos, signs, and so on. Second, whenever I walk through bookstores or shops, I notice items that I want to personalize. Seeing blank covered notebooks always get me excited because they are easy to personalize and can be a thoughtful gift to others.

You can personalize the cover of the notebook by writing the recipient's name, a phrase, or an encouraging note. In this project, we will write *dolce vita* (which means "a sweet life" in Italian) along the edge of the notebook. I will show you how to use a white pencil to sketch out your design before inking it with a brush pen.

Supplies

- A5 Kraft notebooks
- Copperplate/Engrosser's graph pad
- Mechanical pencil
- General's charcoal white pencil
- Brush pen (Pentel Sign Pen Brush)
- Eraser
- Gel pen (Sakura white gel pen)

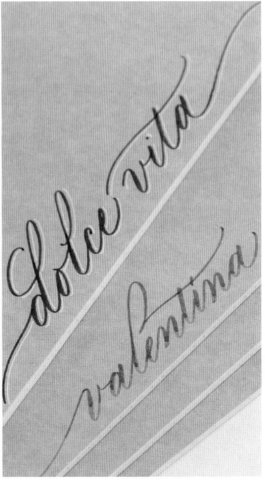

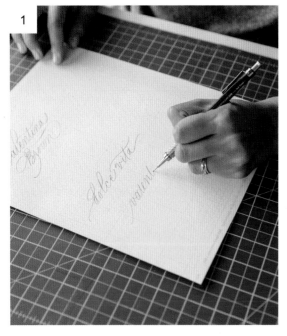

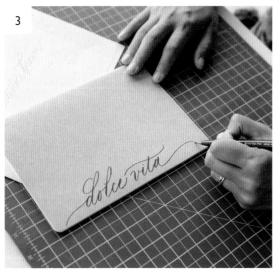

1. Keeping the notebook size in mind, sketch out your designs on the Copperplate/Engrosser's graph pad with a mechanical pencil.

2. With the charcoal white pencil, lightly write along the edge of the notebook to make sure it fits in the space.

3. Ink over the white pencil with your brush pen. After you finish, erase the white pencil marks.

4. To add some highlights, outline the right side of the brush pen strokes with the gel pen.

5. **Variation.** Add another layer on the top part of the brush lettering to create an ombré effect.

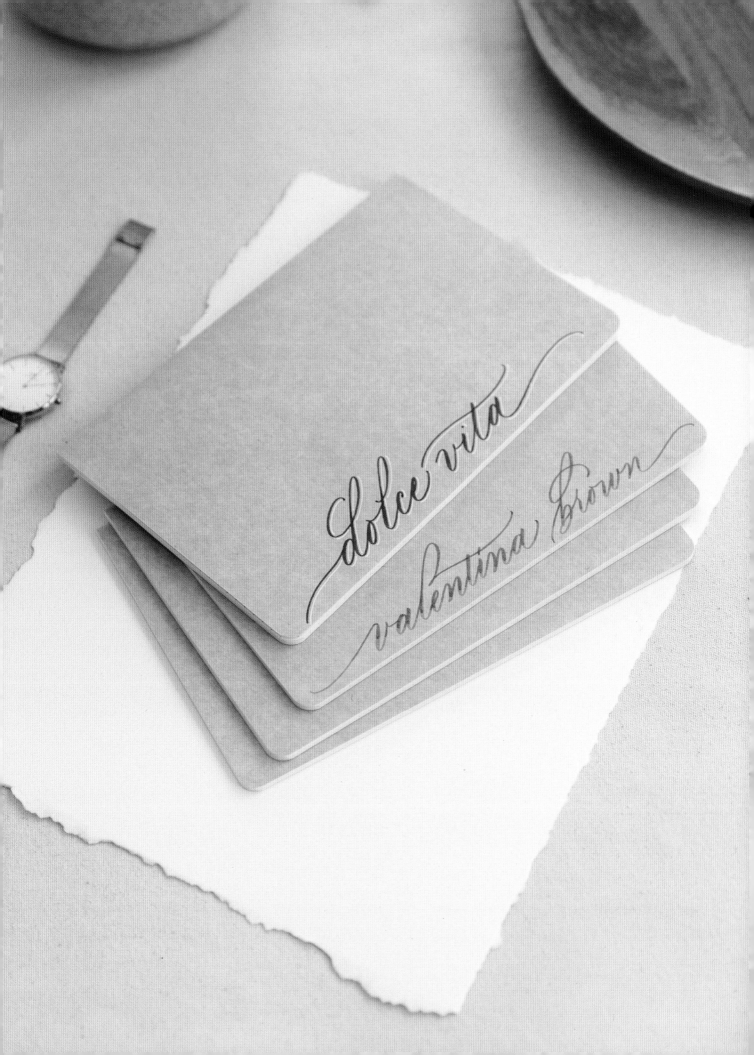

Bookmark

My oldest son is an avid reader. Whenever we go out, he makes sure to pack a book or two for the car ride. I love watching him read because it reminds me that nothing can replace the experience of holding a book in our hands and flipping through the pages. Sometimes when I am reading, depending on the book, I will keep my pens nearby to highlight, underline, and jot down notes along the sides of the pages. That helps me process and soak in the information.

For this project, you will make your own bookmark with self-adhesive laminating sheets. These sheets are a great alternative if you do not own a laminating machine and will protect your bookmark from getting damaged. We are going to take a popular French saying, *Vouloir, c'est pouvoir*, which means "Where there's a will, there's a way" and paint a light wash background with gold elements. This can be a thoughtful gift for your book-loving friends and family!

Supplies

- Paper trimmer
- White mixed media paper (Van Gogh Mixed Media)
- 1 inch (2.5 cm) wash brush
- Blue watercolor paint
- Pearl Ex, Aztec Gold
- Toothbrush
- Black brush pen (Pentel Touch Sign pen)
- Self-adhesive laminating sheets
- Copperplate/Engrosser's graph pad
- Pencil
- Eraser
- Hole puncher
- Light pad
- Ribbon

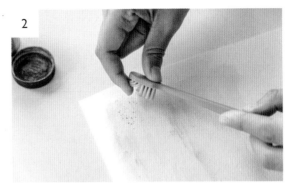

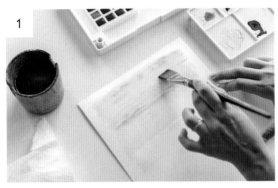

1. With a 1 inch (2.5 cm) wash brush, paint a layer of blue watercolor onto a sheet of mixed media paper. Use the edge of the brush to add more pigment for a layered effect.

2. Pour a bit of Pearl Ex into the cap and pick up some of the powdered pigment with a toothbrush. Flick the bristles of the toothbrush to add specks of gold onto the paper. You can also use the toothbrush to smooth out the gold pigment across the paper. After the paper dries, use the paper trimmer to cut it down to 2 x 7 inches (5 cm x 18 cm).

3. Draft a sketch of the quote using the Copperplate/Engrosser's graph pad and a pencil.

4. Place the final paper on top of the pencil sketch and place it on top of the light pad. Use a black brush pen to write the quote on the paper.

5. Flip the bookmark over and place it on one laminating sheet. Place a second laminating sheet on top and press down firmly. Using the paper trimmer again, cut off the excess laminating sheet, leaving about ¼ inch (0.5 cm) from the edges.

6. Hole-punch one end of the bookmark. String a ribbon through the hole, tie it, and cut off the ends.

Vision Board

If you haven't heard of a vision board, it's a collage of photos, words, and phrases that you want to envision or dream for your life. Usually people create a personal vision board before the start of a new year. You can keep the board generic to include different areas of your life or be more specific (health, relationships, travel, career, etc.). After you are done, find a place for your board where you can see it so that you can be reminded of your aspirations and priorities!

Supplies

- Cork board
- Photos
- Card stock paper
- Binder clips
- Thumbtacks
- Brush pen (Pentel Sign Touch pen)
- Water brush pen
- Light pad
- Pencil
- Copperplate/Engrosser's graph pad
- Washi tape
- Scissors

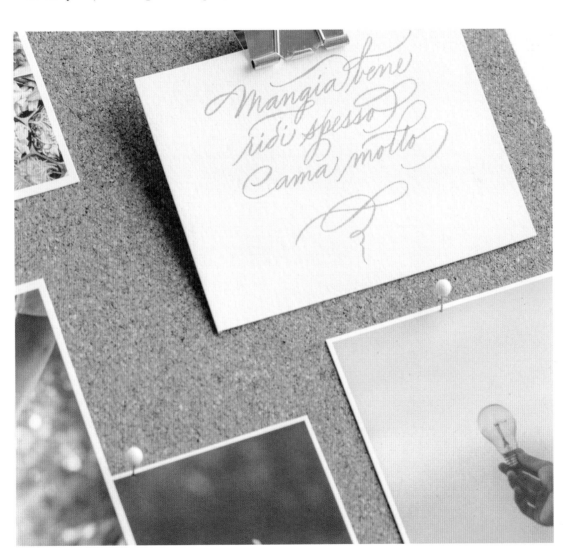

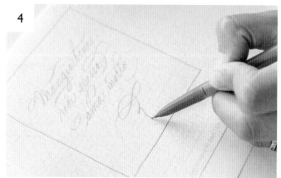

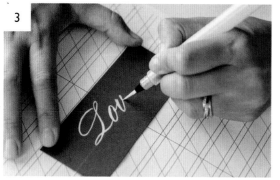

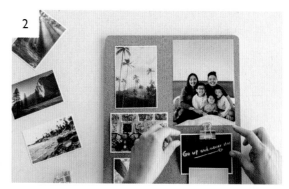

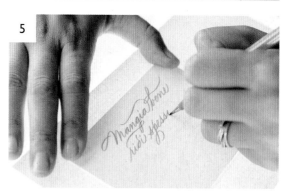

1. Take some time to browse through magazines or photos to gather the images that you want to include on your vision board. If you don't have access to magazines, a great website to download free, high-resolution photos is Unsplash. Just search for the topic that you are looking for and download to print any images that catch your attention. Arrange the photos on your cork board. If you are including multiple categories, you may want to group them together on the board.

2. Once you are happy with your layout, thumbtack the photos to secure them to the board. For some of the photos, I used binder clips to add dimension to the board.

3. Next, cut your card stock paper to 2 x 4 inches (5 cm x 10 cm) to write down a word to accompany the visual images. **Note:** The size will depend on the size of your board as well as the length of your word. Place the colored card stock on top of your guide sheet and use the laser level to mark your baseline. Dip your water brush into the white ink and write out your word.

4. If you are writing a short quote or a phrase, make sure to sketch it out first on the graph pad with a pencil.

5. Place the final paper on top of the sketch and use the light pad to ink it with a brush pen. Use washi tape or binder clips to secure the words or phrases onto the board.

Multicolored Alphabet Print

Next time you sit down to practice letters, add some color and switch between Copperplate and Spencerian to create a finished piece that you can frame! This project is a fun way to implement the scripts you have learned and to practice writing with a brush pen.

Supplies

- Paper trimmer
- Copperplate/Engrosser's graph pad
- Mechanical pencil
- Eraser
- Micron 0.3 mm pen

- Light pad
- Canson XL cold-pressed watercolor paper
- Brush pens (Ecoline)
- Washi tape

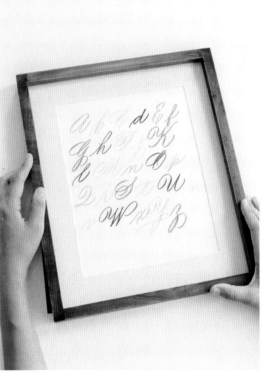

1

2

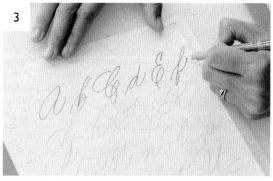

3

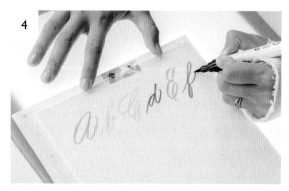

4

1. On the Copperplate/Engrosser's graph pad, mark the size of the print (8 x 10 inches [20 cm x 25.5 cm]) and evenly space out the baselines down the paper.

2. With a pencil, sketch out the alphabet by alternating capital and lowercase letters as well as mixing Copperplate and Spencerian scripts.

3. Once you are happy with the sketch, ink it with a Micron 0.3 mm pen to darken the lines so you can see the sketch through the light pad.

4. With a paper trimmer, cut the watercolor paper down to 8 x 10 inches (20 cm x 25.5 cm). Align the watercolor paper on top of the sketch and secure it with washi tape. Working on the light pad, begin to ink the letters using a variety of brush pens.

5. I used the colors Yellow Ochre, Gray, Pastel Blue, Black, and Indigo. When you are finished, it is ready for framing!

5

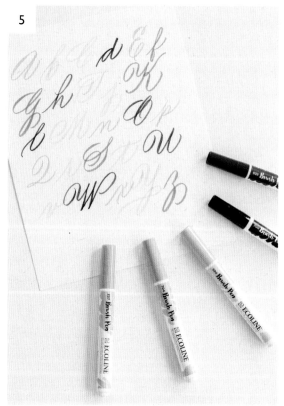

Event Table Card

Whether they are for a baby shower or a dinner gathering, these acrylic table cards will add the perfect modern touch. When writing on acrylic sheets, it's helpful to have alcohol wipes nearby so that you can easily wipe off any mistakes. For this project, we will be making table numbers with a simple illustration on the bottom. I love the white-on-acrylic combination; however, if you want to add a pop of color, I will show you how to paint a colored background.

Supplies

- 5 x 7 inches (12.5 cm x 18 cm) acrylic board
- Copperplate/Engrosser's graph pad
- Pencil
- Eraser

- Ruler
- 2 mm white paint marker (Molotow acrylic paint marker)
- *Optional:* gouache, 1 inch (2.5 cm) wash brush

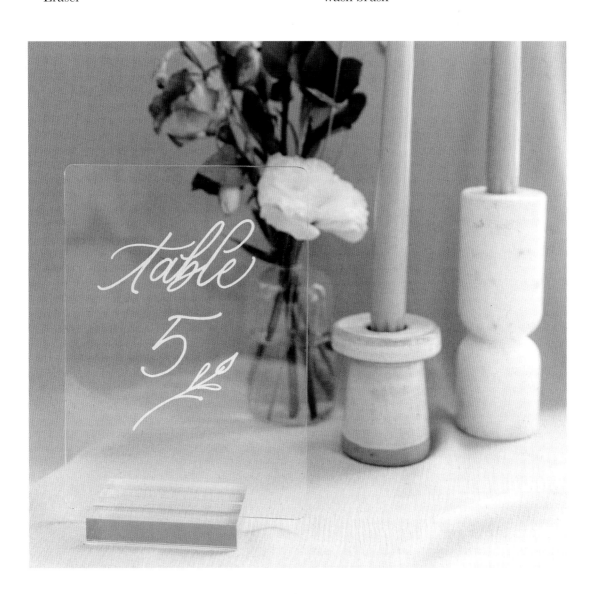

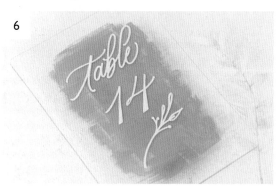

1. Mark off the size of your acrylic sheet on your graph paper with a pencil.

2. Sketch out your design with a pencil and make sure it's centered. Add a simple illustration at the bottom of the sketch. Draw a wavy line first and then add the leaves and berries.

3. Once you are happy with your design, place the acrylic sheet on top of your sketch.

4. Using a paint marker, ink the design onto the acrylic sheet.

5. **Variation.** To add a colored background, wait until the paint side is dry. Turn the acrylic sheet over and paint a background using gouache and a 1 inch (2.5 cm) wash brush. You want to make sure you cover all the lettering and/or illustration.

6. The painted background will give the table card a nice textured look.

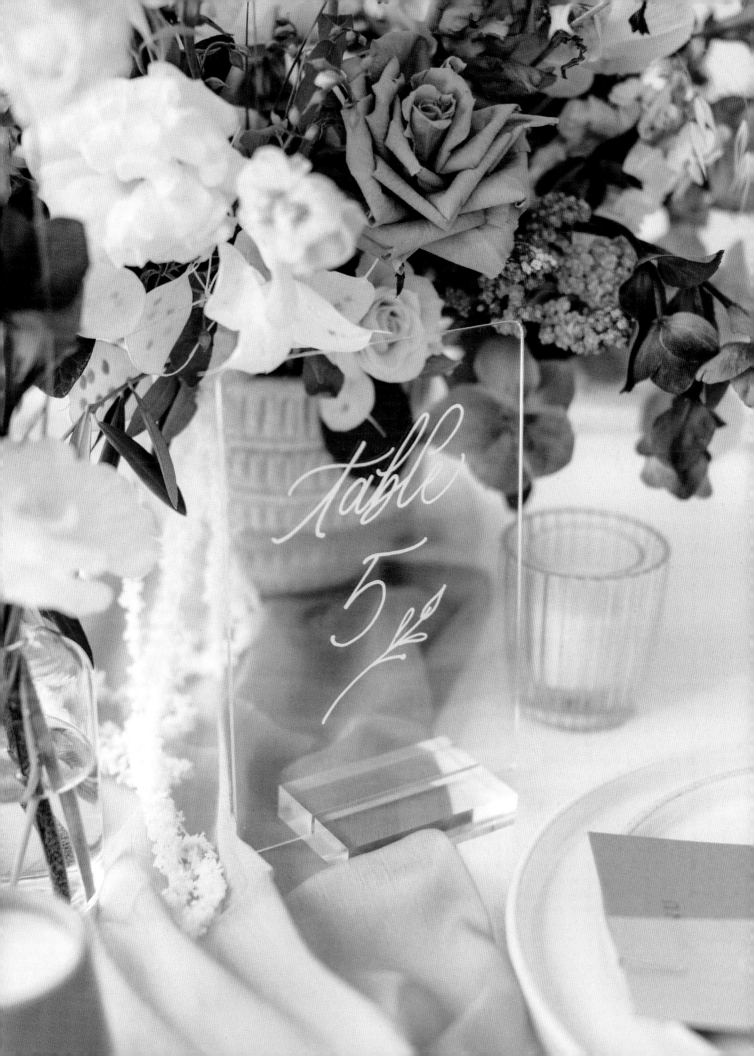

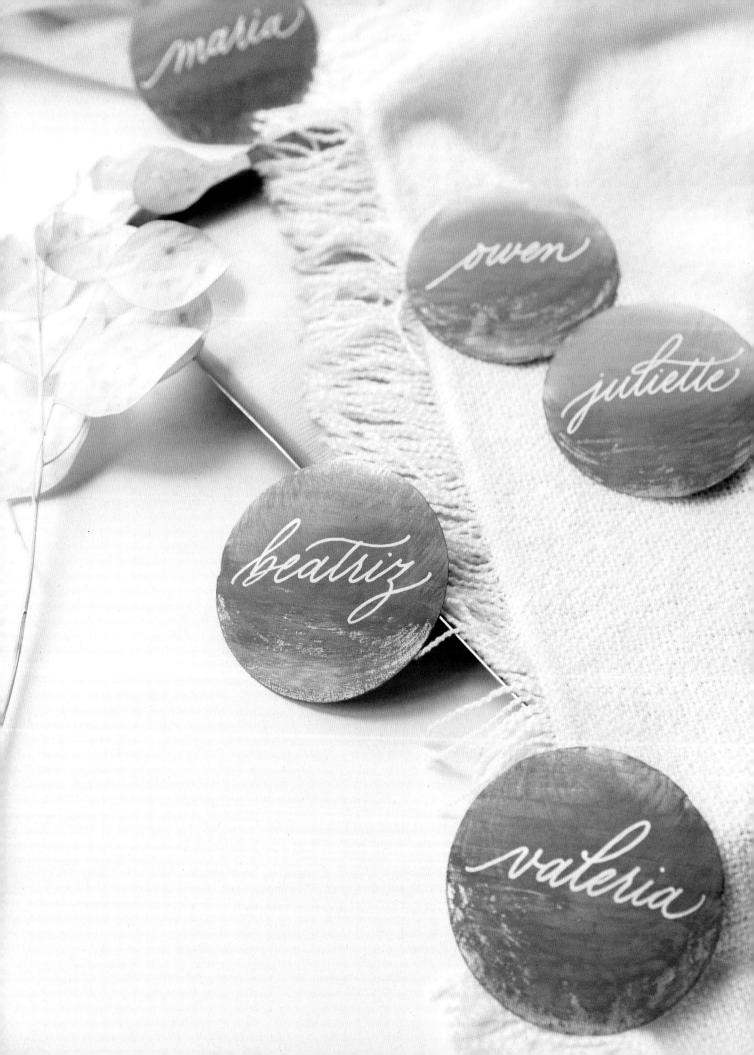

Capiz Shell Place Cards

Now that you know how to write letters using any pen, you can try writing on non-traditional writing surfaces such as rocks, leaves, pumpkins, and shells. For this project, we will write on capiz shells, which you can use as place cards or party favors for your next celebratory event. The shells have a bit of texture and are slightly translucent, so we will paint a mix of gray and gold background before writing with a white pen.

Supplies

- 3 inch (7.5 cm) capiz shells
- 1.5 mm paint marker (Molotow paint marker)
- Gold and gray gouache (Arteza gouache tubes)
- Watercolor palette
- 1 inch (2.5 cm) wash brush
- Cup of water
- Wax paper
- *Optional:* Laser level

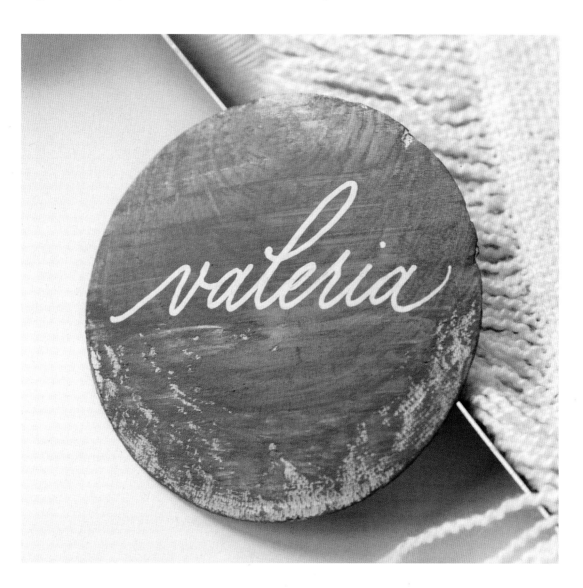

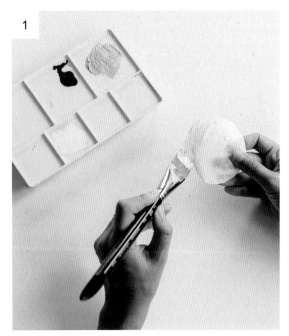

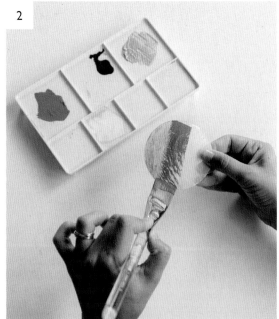

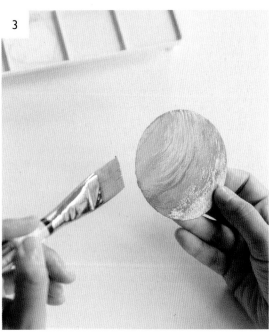

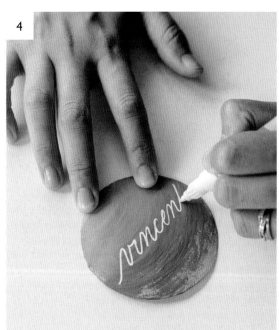

1. Squeeze a bit of gold and gray gouache onto the palette. Dip the 1 inch (2.5 cm) wash brush into water and load the gold gouache by brushing it back and forth on the palette. Paint a layer of gold on about one-third to one-half of the shell. Rinse your brush.

2. Load the gray gouache onto your brush and paint the rest of the shell. There will be some overlap with the gold gouache, but you want to leave the lower part of the shell in all gold.

3. To create a gradient look, dip your brush into water and slowly dilute the gouache as you paint toward the top.

4. Repeat with remaining shells. Place the painted shells on the wax paper and wait until they are fully dry. Write the names using a 1.5 mm paint marker and you're done!

Optional: Use a laser level to mark your baseline as you write.

Personalized Ornaments

One of our family winter traditions is decorating the tree together. After dinner, we put on our pajamas, turn on some festive music, and bake cookies, and my favorite part is opening up our ornament box. Our ornaments are a mix of random things we've accumulated and collected over the years, including ornaments from places that we traveled to, photo ornaments of the boys when they were babies, and handmade Pokémon paper ornaments that the boys drew and made.

Making your own ornaments is a fun way to get crafty with your friends and family. You can write on acrylic flat circles, but I like these round plastic balls because you can fill them with a variety of things (snowflakes, artificial pine leaves, berries, etc.).

Supplies

- Plastic ball ornaments
- 1.5 mm acrylic paint marker (Molotow acrylic paint marker)
- Stabilo aquarellable white pencil
- Artificial snowflakes
- Metal funnel
- Cup
- Paper towel
- Ribbon

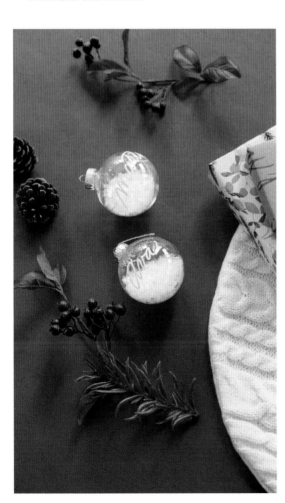

1. Pour some artificial snowflakes into a cup. Remove the cap of your ornament. Then, using a metal funnel, pour the snowflakes into your plastic ball ornaments. I like to fill each ball up anywhere between one-third and one-half full.

2. With a Stabilo pencil, sketch out the name on the ornament until you are happy with the placement and letters.

3. Holding the ball steady with one hand, begin writing the name with the acrylic paint marker. When the marker is fully dry, use a piece of paper towel to wipe off the pencil marks.

4. Add a ribbon to your personalized ornament, and it's ready to be hung on your tree!

Tip

If you make a mistake, no worries. Just remove it with an alcohol wipe, wait for it to dry, and try again.

Monogrammed Pen Pouch

A monogram is a design created by overlapping two or more letters. You can write the letters in the same size or make the center one slightly larger. Though they are widely used for weddings and even business logos, you can add a personalized monogram to your everyday items such as a pouch to make them extra unique and special. The pouch can be used to store your art supplies, makeup, phone chargers, etc. This project is a great opportunity for you to implement the flourishes that you learned in this book.

Supplies

- Copperplate/Engrosser's graph pad
- Pencil
- Pouch
- Black carbon paper

- Ballpoint pen
- Washi tape
- Fabric pen
- Scissors

1. Take some time to sketch out some monogram options on the Copperplate/Engrosser's graph pad with your pencil. Make sure to take measurements of your pouch so that the design will fit in the space. When you are happy with your design, cut it out with your scissors.

2. Cut the black carbon paper to fit the design and place the darker side facing down on the pouch.

3. Place the sketch on top of the carbon paper and tape it to lightly hold it in place.

4. Using a ballpoint pen, trace the sketch firmly.

5. When you are finished, gently lift the carbon paper off, and you should see a faint black sketch remaining on the pouch.

6. Write over the sketch with the fabric pen. Feel free to go over it multiple times to darken the lines.

Heart-Shaped "Love" Card

When we got married, I remember someone gave us the advice to say the following to each other on a regular basis: "I'm sorry," "Please forgive me," and "I love you." Now I realize the power of those three sayings, especially the last one. Whether it's for someone in your family or a friend, let's take the time to say "I love you" as much as we can. In this project, we will write in Spencerian script and create a unique handmade card. If you don't have a scorer, you can create this as a flat card.

Supplies

- Paper trimmer
- Scorer
- Bone folder
- White watercolor paper (Canson XL watercolor paper)
- Pink card stock paper
- Heart stencil
- 0.5 mm mechanical pencil
- Sakura white gelly roll pen
- Glue stick
- Sharpie fine point gold permanent marker
- Black gel pen
- Laser level
- Guide sheet
- Scissors

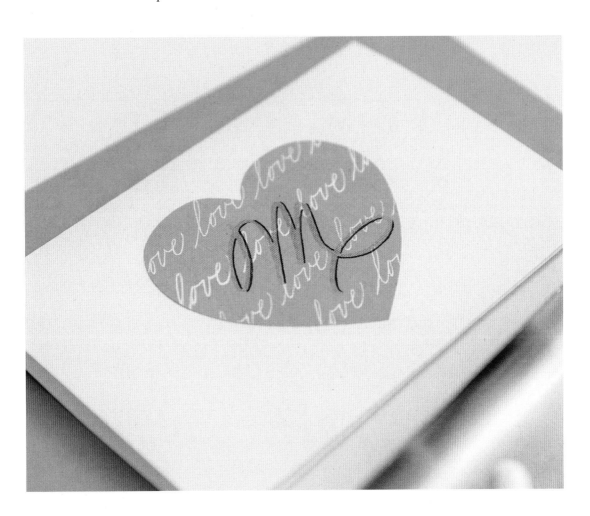

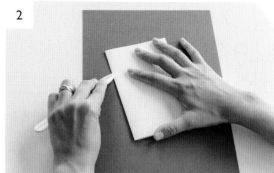

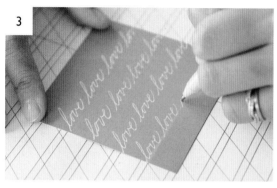

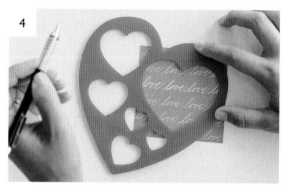

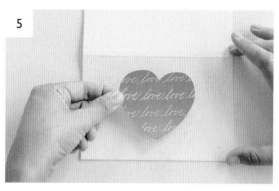

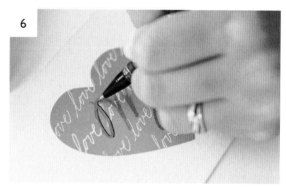

1. Cut paper to 6 x 8 inches (15 cm x 20 cm) and score along the center so that your card is 4 x 6 inches (10 cm x 15 cm).

2. Using a bone folder, press down along the edge where you scored the paper to create a clean fold.

3. Cut the pink paper to 3 x 3 inches (7.5 cm x 7.5 cm). Place the pink paper on top of the guide sheet and write "love" repeatedly with the white gelly roll pen. Use the laser level to mark your baseline.

4. Outline the heart shape with a heart stencil lightly with a pencil.

5. Cut out the heart with scissors and glue it to the front of the card.

6. With a Sharpie gold marker, write the initial of the recipient. To make the initial letter stand out more, add a shadow using the black gel pen along the right side of the initial.

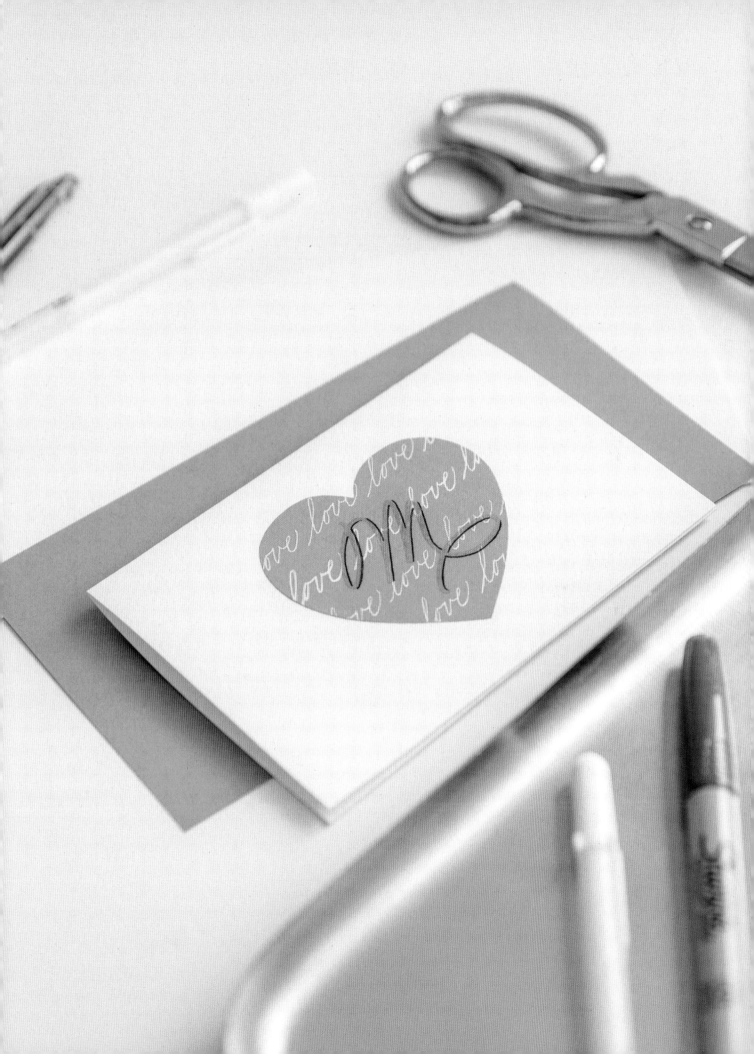

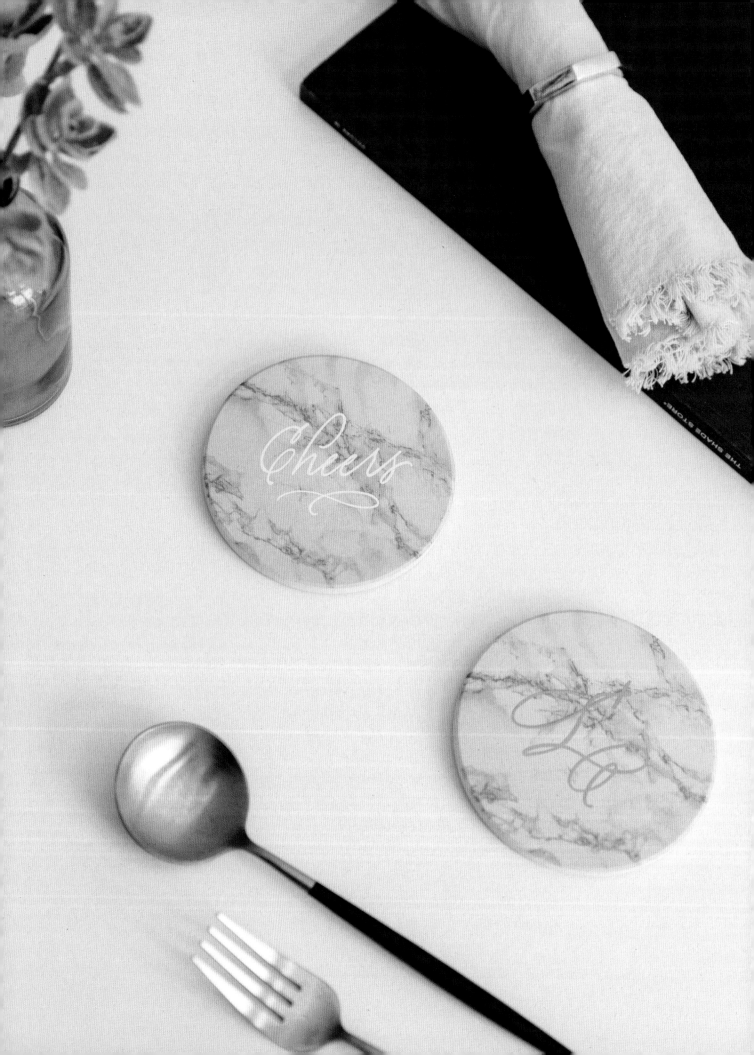

Marble Coasters

If you are in need of a housewarming gift idea, look no further! These marble coasters can be personalized and are created to last. For this project, I recommend getting at least a 4 inch (10 cm) coaster to have sufficient space to write. You can keep it simple by writing in monoline or write in faux calligraphy to add weight to your letters. I will be using a permanent marker, but you can also write with an acrylic paint marker. Because of the space, I recommend either initials or short phrases such as "Cheers," "Mr.," "Mrs.," "Love," and "Joy" to keep it from looking too crowded.

Supplies

- Copperplate graph pad
- 4 inch (10 cm) round marble coasters
- 0.5 mm mechanical pencil
- Sharpie fine point gold permanent marker
- Laser level

- Cutting mat or guide sheet
- Wax paper
- Protective fixative (Krylon satin finish spray)
- Ribbon

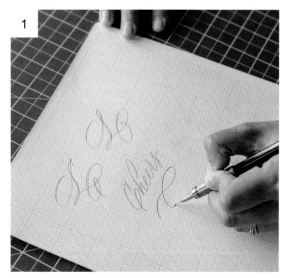

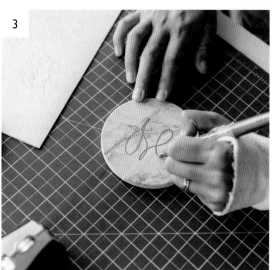

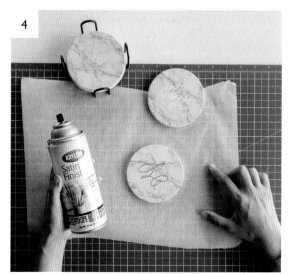

1. Sketch out possible designs you want to write on the coasters using a pencil.

2. Place the coaster on the cutting mat (or guide sheet) and use the laser level to mark the baseline.

3. Write out the letters using the Sharpie gold permanent marker.

4. Place the finished coasters on wax paper and finish them with the Krylon satin spray. This will provide a permanent, waterproof finish that will not yellow with age.

5. Tie the coasters together with a ribbon and they're ready to be gifted!

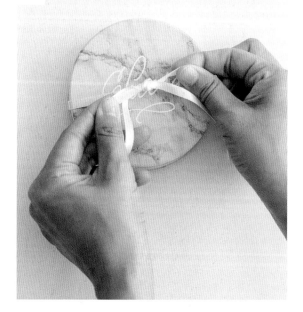

Garden Labels

My mother started to grow her own backyard garden, and I am so amazed every time she sends me photos of all the zucchini, cucumbers, peppers, and tomatoes that are abundantly growing. Though I am not a natural at gardening, she has inspired me to start small and not give up. For this project, we will be making our own garden labels to identify each plant. I'm excited for you to use these labels to add to the decor and beauty of your garden!

Supplies

- Wooden craft sticks
- Painter's tape
- 1 inch (2.5 cm) wash brush

- 2 mm white and black paint markers (Molotow acrylic paint markers)
- Acrylic ink (Amsterdam acrylic ink, Oxide Black)

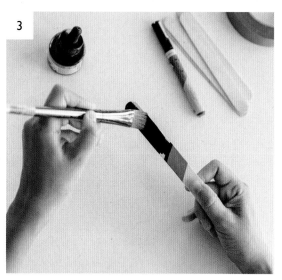

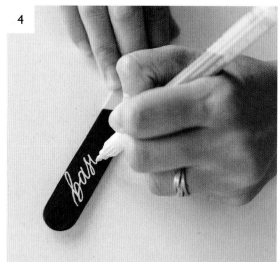

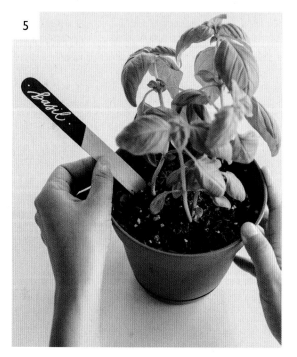

1. Place a piece of painter's tape at a diagonal line on the wooden craft stick. With the 2 mm black paint marker, draw a line along the painter's tape.

2. Drop some Amsterdam acrylic ink on the area above the tape.

3. Apply the ink with the 1 inch (2.5 cm) wash brush. Make sure to also paint the sides of the stick.

4. After the black ink dries, use the white paint marker to write the names of the herbs, vegetables, and other plants you will be growing in your garden. Draw a small dot on each side of the word.

5. Insert each stick into the soil next to its corresponding plant and you're done.

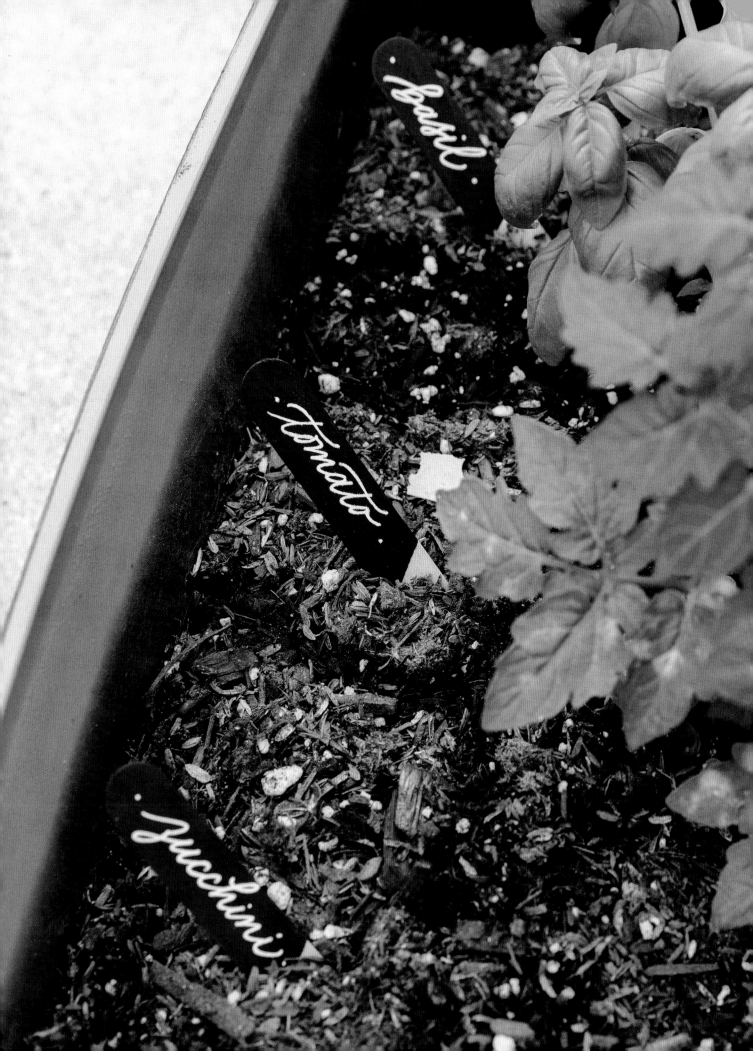

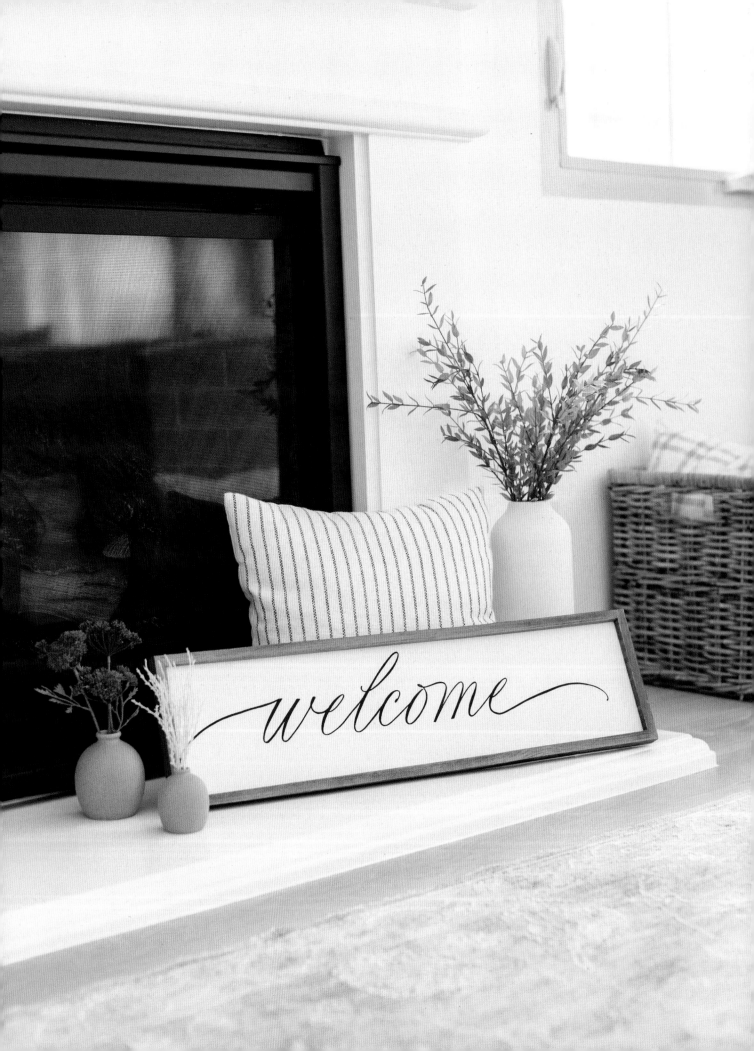

"Welcome" Wooden Signage

I love and appreciate home decor. When I visit someone's house, I tend to notice the aesthetics, the kind of signage they have on the walls, the photos, and the collection of items they have around the house. I feel that there's always a story waiting to be told. In this project, we will be working on a wooden sign together. The wooden element will add a rustic but warm feel to your home. Though writing on wood can be tricky, I'll be sharing my tips and techniques so that you can have a sign that lasts.

Supplies

- Wood (either unfinished or finished)
- Copperplate/Engrosser's graph pad
- Measuring tape
- 0.5 mm mechanical pencil
- 1.5 mm and 2 mm Molotow black acrylic paint markers
- Laser level
- *Optional:* Fixative spray

Tip

If you are working with an unfinished wood surface, it's best to first spray a layer of polyurethane so that the marker does not bleed on the wood.

1. Sketch out how you will write "welcome" with a pencil. You can scale down the size to make a thumbnail sketch.

2. If you are scaling down your sketch, it's important to mark where the letters will begin and end so that the word will be centered on the final sign. For example, for this piece, I want to make sure the letter *w* will begin at 5¾ inches (14.5 cm) and the final letter *e* will end around 20 inches (51 cm). It doesn't have to be exact, but this will help you as you sketch the design on the sign.

(continued)

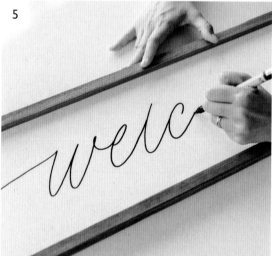

3. Using the measuring tape, mark off where you want to begin and end your word.

4. Place the laser level on the sign to mark the baseline and lightly sketch the word "welcome" with a pencil.

5. Once you are happy with the pencil sketch, ink over the sketch with the 2 mm paint marker. If you like the strokes to be thicker, you can use a 4 mm marker.

6. Using a smaller 1.5 mm paint marker, add additional lines to create faux calligraphy and color it in to create the thick downstrokes. Wait for the ink to dry and erase the pencil marks with an eraser. **Optional:** Once everything is done, spray the finished signage with a fixative to seal it all together.

Sample Guide Sheets

I've included sample guide sheets that you can use for Copperplate, Spencerian, and brush calligraphy. For the brush guide sheet, you can use one x-height for smaller pens and adjust depending on the size of the pen tip. You can download additional guide sheets at logoscalligraphyshop.com/collections/downloadables.

Copperplate Guide Sheet

x

x

x

x

x

x

x

x

x

x

x

x

x

x

x

x

x

x

Brush Lettering Guide Sheet

Resources

To download more guide sheets: logoscalligraphy.com/classiccalligraphy

CALLIGRAPHY SUPPLY SHOPS

John Neal Books: johnnealbooks.com

Logos Calligraphy Shop:
 logoscalligraphyshop.com

Paper and Ink Arts: paperinkarts.com

PAPER AND ENVELOPES

Borden & Riley: bordenandriley.com

Canson: en.canson.com

LCI Paper Company: lcipaper.com

Paper Source: papersource.com

Rhodia: rhodiapads.com

Strathmore: strathmoreartist.com

PAINTS, BRUSHES, AND OTHER SUPPLIES

Arteza: arteza.com

Cedar Group: cedar-group.net

FINETEC: finetecus.com

Princeton Artist Brush Company:
 princetonbrush.com

Royal Talens: royaltalens.com

Sakura of America: sakuraofamerica.com

Winsor & Newton: winsornewton.com

PENHOLDERS

Ash Bush: ashbush.com

Dao Huy Hoang: huyhoangdao.com

Inkmethis: inkmethis.com

Jake Weidmann: jakeweidmann.com

Luis Creations: luiscreations.com

Tom's Studio: tomsstudio.co.uk

Unique Oblique: uniqueoblique.com

Written Word Calligraphy:
 writtenwordcalligraphy.com

Yoke Pen Co.: yokepencompany.com

HANDMADE PAPER

Fabulous Fancy Pants:
 fabulousfancypants.com

Feathers and Stone: feathersandstone.com

Inquisited: inquisited.com

Oblation Papers & Press:
 oblationpapers.com

SHare Studios: sharestudios.me

Acknowledgments

My deepest gratitude to those who have helped bring this book to life.

To my one and only, Tim. Thank you for always believing in me and supporting my dreams. From brainstorming names and projects for my business to helping me fulfill shop orders to watching our three boys and going the extra mile to give me the space and time that I needed for this book . . . you are the real MVP. Thank you for being my biggest cheerleader.

To Jordan, Jacoby, and Jude, you boys are my inspiration and motivation.

To my editorial director, Joy A. For a long time, I held off on working on a book until I found the right publisher and team. Chatting with you over the phone for the first time was what brought confirmation to move forward. Thank you for your patience, for listening to my heart and vision for this book, and for helping produce something we can both be proud of! To Marissa, Liz, and the rest of the Quarto team, thank you for all your expertise, help, and support throughout the entire process.

To Joy L., an amazingly talented photographer and friend. I'm always in awe of how you are able to produce beautiful photos in such a meaningful way. I will forever treasure the photos you captured of my pregnancy with Jude, with the grandparents, and now for this book. Thank you for going above and beyond to bring my vision to life.

To Amy. Thank you for all your help in styling and working your magic! I have a deeper appreciation for stylists and event planners after seeing what you did for some of the projects (place cards, menu, event card) in this book. You have an incredible ability to bring elements together in a timeless way, and I am so thrilled with how everything came out.

To Hannah K. from Milieu Florals and Hannah J. from Hana by Hannah. Thank you for your exquisite florals, which added the perfect touch to what we had envisioned for the styled shoots.

To Jinyoung. Thank you for your willingness to step in and help in whatever way I needed. From making the cheeseboard to welcoming us into your beautiful home to feeding us with your homemade salad to make sure we were taking care of ourselves—I'm thankful for your support and friendship.

To my family. Umma and Appa, thank you for cheering me on, for your love, and for pointing me to what is truly important. I wouldn't be here without you. To my beloved mother- and father-in-law, thank you for your unconditional love and for covering our family with your endless prayers. To Unnie and Paul, thank you for being there from the beginning of this journey and opening up your home for the boys to sleep over when I needed to focus on my work. Having you guys nearby has been such a gift and a blessing to us.

To my dear friends. Thank you for your text messages and the phone calls and for checking in throughout this journey. You know who you are. I'm grateful to be doing life together with you.

To the wonderful calligraphy instructors that I've had the privilege to learn under including Kaye Hanna, Harvest Crittenden, Barbara Calzolari, Bill Kemp, Heather Held, Michael Sull, and more. To Kaye Hanna, thank you for being such a pivotal part of my journey. Your tender guidance, encouragement, beautiful script, and willingness to share is what drew me into calligraphy and makes me want to continue on my journey. To Michael Sull, meeting you at the LA Pen Fair in 2016 was such a turning point to my writing experience when you encouraged me to try writing with an oblique pen again. I'm grateful for the opportunity I had to learn Spencerian from you. You are such an inspiration to many.

And most of all, to God, from which "all things were created through Him and for Him" (Col 1:16). Thank you for writing my story and bringing this gift of calligraphy into my life during a season when things seemed hopeless. May You receive all glory and praise.

About the Author

Younghae Chung is a classically trained left-handed calligrapher, teacher, and creative entrepreneur. After working in a New York City advertising agency and a nonprofit organization for more than ten years, she decided to pursue her passion for the arts and teaching and launched Logos Calligraphy & Design in 2016. Younghae's mission is to keep penmanship alive by sharing her joy and love for calligraphy and arts by offering resources, such as workshops, online courses, and products, to help others learn this timeless craft. She has taught thousands of students, both in-person and online, connecting with and cultivating a diverse community of students from more than thirty-five countries worldwide. Find out more about Younghae's work and classes on her website logoscalligraphy.com and on Instagram @logos_calligraphy, Facebook @logoscalligraphy, and YouTube at Logos Calligraphy. She lives in southern California with her husband, Tim, and sons Jordan, Jacoby, and Jude.

Index

© 2022 Quarto Publishing Group USA Inc.
Text, Photos, and Illustrations © 2022 Younghae Chung

First Published in 2022 by Quarry Books, an imprint of
The Quarto Group, 100 Cummings Center, Suite 265-D, Beverly, MA 01915, USA.
T (978) 282-9590 F (978) 283-2742 Quarto.com

Quarry Books titles are also available at discount for retail, wholesale, promotional, and bulk purchase. For details, contact the Special Sales Manager by email at specialsales@quarto.com or by mail at The Quarto Group, Attn: Special Sales Manager, 100 Cummings Center, Suite 265-D, Beverly, MA 01915, USA.

10 9 8 7 6 5 4 3 2 1

ISBN: 978-1-63159-984-2

Digital edition published in 2022
eISBN: 978-1-63159-985-9

Library of Congress Cataloging-in-Publication Data is available.

Design and page layout: Laura Shaw Design
Photography: Joy Theory Co

Printed in China